NO EXPERIENCE REQUIRED!

DRaWiNG and PAiNTiNG ANiMaLS

NO EXPERIENCE REQUIRED!

DRaWiNG and PAiNTiNG ANiMaLS

Cathy Johnson

NORTH LIGHT BOOKS
CINCINNATI, OHIO
www.artistsnetwork.com

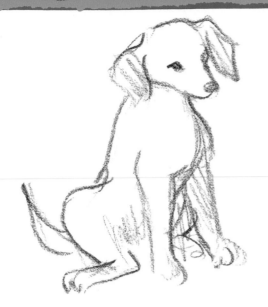

Dedication

Every woman, no matter how strong, needs a knight at some point in her life. This book is dedicated to mine.

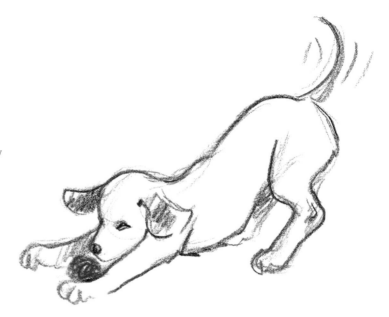

No Experience Required: Drawing and Painting Animals. Copyright © 2005 by Cathy Johnson. Manufactured in China. All rights reserved. No part of this book may be reproduced in any form or by any electronic or mechanical means including information storage and retrieval systems without permission in writing from the publisher, except by a reviewer who may quote brief passages in a review. Published by North Light Books, an imprint of F+W Publications, Inc., 4700 East Galbraith Road, Cincinnati, Ohio, 45236. (800) 289-0963. First Edition.

Other fine North Light Books are available from your local bookstore, art supply store or direct from the publisher.

09 08 07 06 05 5 4 3 2 1

DISTRIBUTED IN CANADA BY FRASER DIRECT
100 Armstrong Avenue
Georgetown, ON, Canada L7G 5S4
Tel: (905) 877-4411

DISTRIBUTED IN THE U.K. AND EUROPE BY DAVID & CHARLES
Brunel House, Newton Abbot, Devon, TQ12 4PU, England
Tel: (+44) 1626 323200, Fax: (+44) 1626 323319
Email: mail@davidandcharles.co.uk

DISTRIBUTED IN AUSTRALIA BY CAPRICORN LINK
P.O. Box 704, S. Windsor NSW, 2756 Australia
Tel: (02) 4577-3555

Library of Congress Cataloging in Publication Data
Johnson, Cathy
No experience required : drawing & painting animals / Cathy Johnson.
 p. cm.
Includes index.
ISBN 1-58180-607-8 (pbk. : alk. paper)
1. Animals in art. 2. Painting—Technique. 3. Drawing—Technique. I. Title.

N7660.J65 2005
743.6--dc22 2004030780

Edited by Vanessa Lyman
Art direction by Wendy Dunning
Interior design and production by Jenna Habig
Production coordinated by Mark Griffin

METRIC CONVERSION CHART

To convert	to	multiply by
Inches	Centimeters	2.54
Centimeters	Inches	0.4
Feet	Centimeters	30.5
Centimeters	Feet	0.03
Yards	Meters	0.9
Meters	Yards	1.1
Sq. Inches	Sq. Centimeters	6.45
Sq. Centimeters	Sq. Inches	0.16
Sq. Feet	Sq. Meters	0.09
Sq. Meters	Sq. Feet	10.8
Sq. Yards	Sq. Meters	0.8
Sq. Meters	Sq. Yards	1.2
Pounds	Kilograms	0.45
Kilograms	Pounds	2.2
Ounces	Grams	28.4
Grams	Ounces	0.04

About the Author

Artist, writer and naturalist Cathy Johnson has been drawing and painting all her life. She is the author and illustrator of thirty books, including *Creating Textures in Watercolor, First Steps: Painting Watercolor, First Steps: Sketching & Drawing, Watercolor Tricks and Techniques* and *Watercolor Pencil Magic* (all from North Light Books).

A full-time freelancer, Johnson has written articles for *Artist's Sketchbook, Sports Afield, Early American Life, Science Digest, Harrowsmith Country Life, Mother Earth News* and many other publications. Currently, she is a contributing editor for *The Artist's Magazine* and *Watercolor Magic*, and she was a contributing editor for *Country Living* for eleven years. She began publishing books relating to her hobby as a living-history interpreter nine years ago under her imprint, Graphics/Fine Arts Press.

Johnson's artwork also is included in various private and corporate collections. She lives in a small town in Missouri with her many cats and enjoys traveling to the rest of the world.

Acknowledgments

This book, like so many others, is the result of many hands and minds. First, thanks go to my wonderful editor, Vanessa Lyman, who kept me steady on course; to Pam Wissman, acquisitions editor at North Light, who believed in the project from the first, and to Greg Albert, editor on almost all of my earlier North Light books, who taught me how to be a professional. Thanks to my copyeditor, Nancy Harward, and art director, Wendy Dunning, as well—without them this would not have been the book it is. There are so many to thank... if I've overlooked anyone, please accept my apologies. You know how much I appreciated your help! If there are mistakes here, it is my own fault, not theirs.

Many, many friends encouraged me, offered suggestions or advice, read sections of the book, let me draw and photograph their animals, and took me out to eat when I needed a break. In no particular order, my profound gratitude to Joy Smith; Pete and Nancy Rucker, Pam and Ed Piepergerdes, and the staff at Excelsior Springs Animal Clinic; the Keith Bowen family (and animals!); my godchildren Ann, Aaron, Molly, Rachel and Nora and their parents, Keith and Roberta—artists all.

Ginger and Jim Nelson, Susan and Andy Theroff, Jytte and Torben Klarlund, Betty Bissell, Polly Jaben, Mike Williams, Kathryn Martz, Mara Riley, Yvonne and Richard Busey, Richard Buckman, Joseph Ruckman and the beautiful Sarah provided pets to draw, a cheering section, inspiration, comfort, hand-holding and generally indispensable assistance. I couldn't have done it without you!

A special thanks to the memories of my father, who taught me to love animals, and to my mother, who taught me to draw them... and to the beautiful beagles and cats who were also my family. (At last, they're earning their way in the world!)

Table of Contents

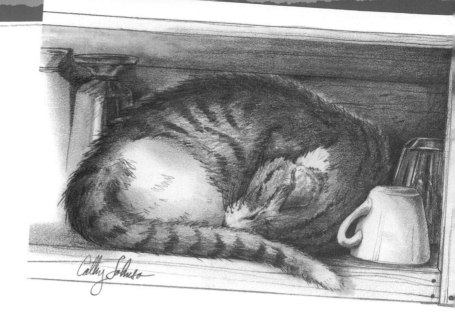

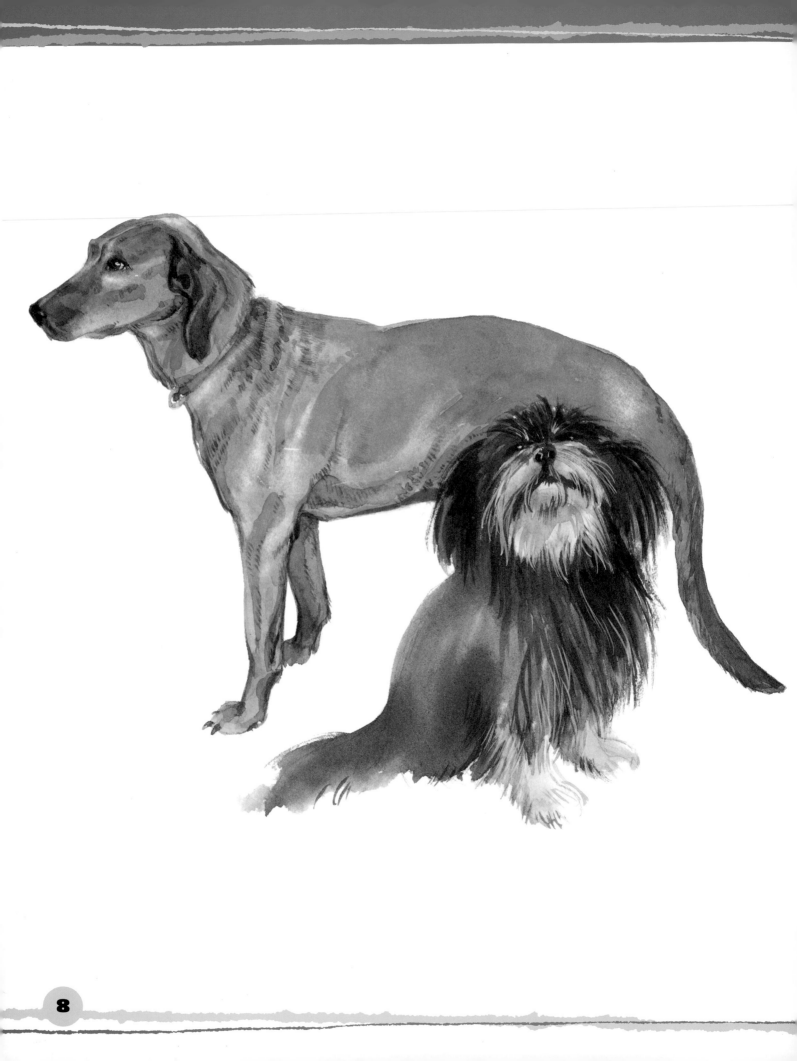

Introduction

Animals have made great subjects ever since the first artists drew on a cave wall with a piece of charcoal and a finger dipped in red clay. Throughout history, we find images of domestic—and domesticated!—animals in art. It's a subject close to our hearts, and as we draw or paint animals, we learn more about them. The cats, dogs, gerbils, turtles, colorful birds and graceful tropical fish that find their ways into our work have the power to touch our viewers and invite a response from the heart.

I am a cat person. Actually, there are those who would tell you I'm just slightly obsessed—but I simply say my animals provide me with endless opportunities for making art. In ways, living with animals is better than a formal course in drawing; I can practice any time, any place, inexpensively and at my convenience. My sketchbooks and journals are full of animal drawings, from the cats I've owned over the years to my childhood dogs to the acrobatic raccoons at the local pet shop. Animals provide a wonderful opportunity to explore some basic drawing and painting techniques, and with a subject more interesting than, say, a dining room chair.

There are a lot of reasons to draw your pets beyond the simple need for practice, of course. For one reason, you love them, or you'd never put up with

the shedding, fur balls and vet bills! That alone gives your drawings an emotional warmth. Believe me, it shows. Years ago, I saw a young boy's drawing of his spotted salamander that sticks in my mind to this day. Now, a salamander is not the warmest or cuddliest of creatures, but the love this young one had for his pet, and his desire to capture the moment, showed unmistakably in his work. It's that sort of emotion that your viewers respond to. Moreover, it's the ability to share that emotion that gives you the deepest satisfaction as an artist.

It's funny how you can tell if someone's done a drawing or painting simply to tug at our heartstrings. Usually it fails—or we're embarrassed to tears when it succeeds (big-eyed sad puppies and fluffy greeting-card kittens come to mind). On the other hand, you can also tell when someone has created an image of a beloved pet simply because they wanted to—and their success can be delightful.

This book offers dozens of tips and a great variety of techniques, both basic and more advanced, for depicting animals. Here, you'll learn to get over the fear of white paper (a common malady among artists!), how to capture animals in motion and how to use your resource photos. There are discussions of the principles of art and color, and suggestions on what to buy and what to try.

You'll practice with pencil, pen and ink, colored pencil, watercolor pencil, watercolor and acrylic.

You'll also find all sorts of step-by-step instructions. These are intended to help you become familiar with the process, but art can't be done by rote. Learn to apply these techniques to your own work. You may even copy the paintings and drawings if you wish, but only for your personal use—*for learning, not for sale!* Copyright issues are a very real concern these days.

But most important, relax and enjoy! Making art should be challenging, satisfying, inspiring and fun!

Getting Started

The best way to get started is to jump right in—with a bit of preparation, of course. (I assume you're motivated, or you wouldn't be holding this book!) Gather your basic supplies to test drive some of these mediums, find a place to work and then—the sky's the limit! Don't let the prospect daunt you. Creating artwork needn't be complicated or expensive. Get your feet wet by trying out new mediums one at a time. Gradually explore new techniques and pick up new equipment along the way. It's great fun—and you'll reap the benefits of a lifelong joy in painting and drawing animals, whether they're your own or someone else's.

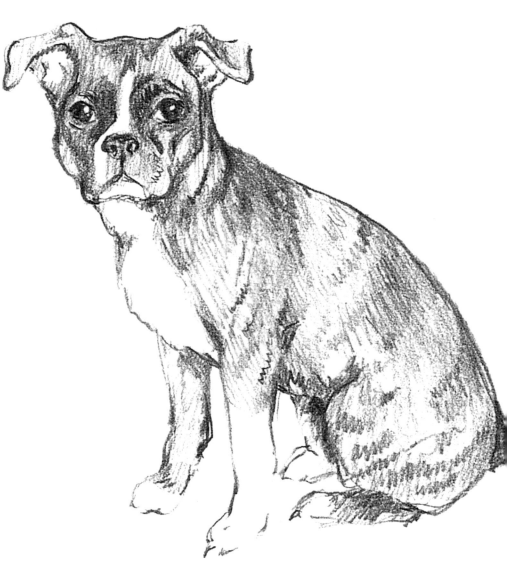

GWEN'S BABY
Graphite
4" × 5" (10cm × 13cm)

What You'll Need

What materials you'll need depends a great deal on what medium you plan to try first. For the absolute basic materials, I'd suggest a sketchbook with decent weight paper, at least 80-lb. (170gsm). This weight is heavy enough to prevent your paper from buckling too badly, and it will take rough handling it might get in the field. Look for one with a medium "tooth," or texture. For now, you don't want a paper so slick that it won't take pencil well or so rough that your pen will skip and stutter. Don't try to get by with too cheap a sketchbook; fighting uncooperative paper is enough to put you off the whole idea!

You might try a spiral-bound sketchbook, or you may prefer a hardbound book, or one with glued sheets, so the spiral wire doesn't get in your way. Stick to smaller sizes as you try them out until you find the paper or papers you like best. For a modest cash outlay, you can purchase a nice spiral-bound watercolor paper sampler. This allows you to try everything from hot-pressed paper to lovely subtle tints.

A no. 2 pencil or an inexpensive fiber-tipped or gel pen will get you sketching. For depicting animals on paper, this is really all you need, but there are plenty of other materials to try. For the basics for each medium, see the chapter about that medium. I don't want to overwhelm you!

You may find a book on animal anatomy helpful. Also helpful is Eadweard Muybridge's *Animals in Motion* (Dover, 1957), a reference of some four thousand individual sequential photographs, including horses, dogs, cats, camels, deer, cockatoos, hawks, goats and many others. Originally shot in the 19th century, these photos are still used by artists today.

WORDS TO KNOW

TOOTH The degree of roughness on a paper's surface. The rougher papers (the ones with more tooth) are ideal for powdery mediums like charcoal or pastel. The smoother papers (ones with less tooth) work better for more fluid mediums.

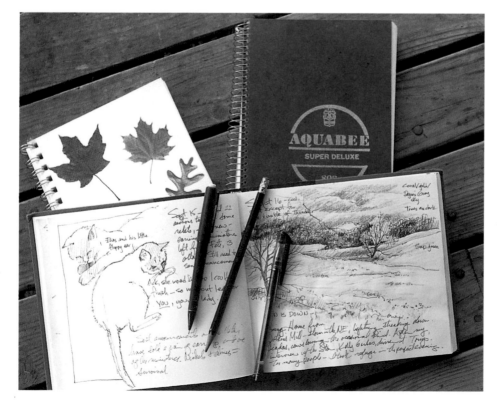

Materials
You don't need much to get started. If a medium intrigues you, start small. I can be happy with my sketchbook, a pencil and a pen, and maybe something for color, like colored pencils or watercolor paints.

Your Work Space

Not everyone has a place set aside for an art studio. If you have an extra room in your house, marvelous. If not, don't let that stop you. You can turn a walk-in closet into a miniature art studio, or simply set aside a corner of the kitchen table, but make room somewhere.

If space is tight, keep your supplies in a canvas tote, art bin, tool chest or even in a knapsack. That way, you'll have a portable studio, even if you have to balance a sketchbook on your knees.

Wherever you work, make sure you have adequate lighting. Natural north light is best, but balanced artificial lighting works well, too. In an art supply catalog, I found an artist's lamp that has both an incandescent and a fluorescent bulb. It gives a very nice, balanced light and was fairly inexpensive. You can also use fluorescent fixtures with a separate incandescent lamp. (Either type used by itself can make it difficult to judge colors; they'll appear too warm or too cool.)

Try to have seating as comfortable possible. A tilted work surface is also good. You can buy a desk with an adjustable surface or a drawing board that tilts, or you can simply prop up your board on your lap and on the edge of a table. Of course, many artists like to work flat—and flat surfaces are much easier to come by. If all you need is a small worktable, a folding card table or sturdy wooden TV tray works very well.

Working Outdoors

If you like working on the spot, you can go as simple or as complex as you like. If you choose, you can have the whole set-up: the folding easel, stool and even an artist's umbrella. But you can also make do with a sketchbook and pencil from an office supply store, working any place you can find room to stand or sit.

For plein air watercolor painting, you'll want to bring along a watercolor box, an inexpensive water container, brushes and paper towels. Take along a cushion or newspapers for a "sit-upon" (as we used to call it when camping), and don't forget the insect repellent and sunscreen. You're set. (I worked this way happily and productively for many years, and only recently bought a French easel.)

WORDS TO KNOW

PLEIN AIR Literally meaning 'open air,' this refers to working outdoors or on location. Most frequently, this term is associated with painting, but any medium may be used outdoors.

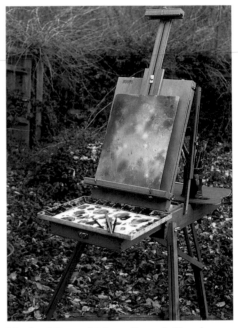

Limited Space? Use a French Easel
Many artists with very limited room in their homes have their "studio" enclosed in a French easel. All they have to do is set it up, open the drawer and, voilà, instant work space! The French easel is also great for working en plein air.

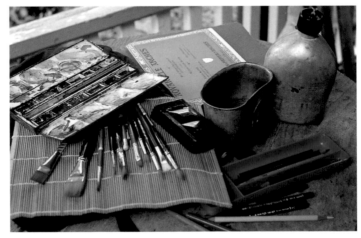

Painting Outdoors
A knapsack with your art supplies is sufficient for many painting situations, indoors or out. My knapsack can contain everything you see above: brushes, a bamboo brush holder, a plastic box of pencils and colored pencils, an old aluminum canteen with cup for my paint water, a block of watercolor paper and an old traveling watercolor box. I have many more supplies at home, but I could happily work for weeks on just what you see here.

Basics of Drawing and Painting: Value

The following pages constitute a kind of miniature art course of the basics: value, composition and color. We'll begin with value.

Whatever your medium—drawing with a pencil, pen and ink, colored pencils, or painting with watercolor or acrylics—the basics of value still apply. In artist's vocabulary, "value" doesn't mean a bargain or an ethical stance, but shades of color, from the darkest dark to lightest light. The simplest example is black (darkest value) and white (lightest value), with all the shades of gray that separate them; each hue has a darkest version of itself and a lightest version of itself.

It's usually best to limit the values in your work to, say, no more than five. You can create the illusion of depth and space quite simply with as few as three values: a dark, a light and a midtone.

Allow either dark or light to dominate your composition in order to keep things from looking too broken up. For example, make your largest area the lightest, make the next largest midtone and confine your darks to small, sharp accents. Or use the midtones for your largest area, the darks for the next largest and the lightest value for the tiny accent. Use this "rule" to create mood or atmosphere. If the darkest darks dominate, for instance, the effect will be moody and dramatic. If you allow the lights to dominate, you'll get a more cheerful picture.

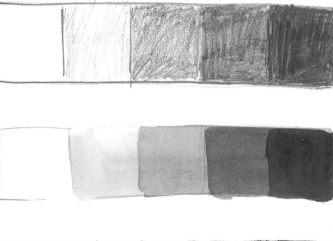

Value Charts
Make yourself a chart with perhaps five values, from the lightest to the darkest. Start with black, white and shades of gray. You can make a chart for medium as a basic visual reminder.

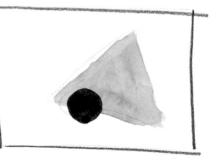

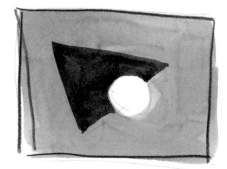

Allow One Value to Dominate
Notice the effect when one value dominates. It's much more interesting than if each value took up equal amounts of space.

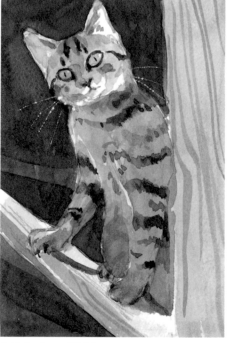

A Painting of Values
Notice how a very limited range of values can still create depth, volume and a sense of reality. Here, my neighbor's cat Pippin stands out against deep shadows. Keep the strongest contrasts where you want the viewer's eye to go—in this case, to Pip's face.

Basics of Drawing and Painting: Composition

Composition involves working with spatial concepts to create a pleasing layout. Some rules are classically simple. The first thing you need to do is decide whether you want to use a vertical (portrait) or horizontal (landscape) format. Sometime a decision like that is simple, but not always. Consider the fact that horizontal compositions tend to be restful, and vertical compositions are more energizing. Does that make you reconsider your vertical sketch of cows laying in a field?

Where you place your center of interest will determine its importance. Experiment with different arrangements and formats until you are pleased with the visual weight of your center of interest.

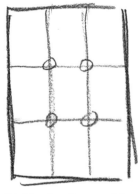 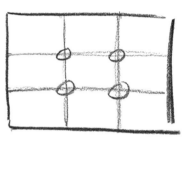

Divide the Composition Into Thirds
Divide your working area into thirds, top to bottom and from side to side, as shown. The center of interest will be most pleasing, in a traditional manner, if you place it at one of the intersections of those lines. This works well, whether you choose a horizontal or a vertical format.

Simple Center of Interest
You may prefer simply to focus all attention front and center for a serene effect.

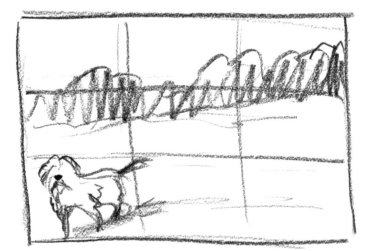

Off Balance
It's not always necessary or even desirable to stick with the classical mode of composition, of course. Explore an off-balance, unusual composition by placing your subject off to one side for a lively sense of motion.

Basics of Drawing and Painting: Color

Color can really bring your work to life, so it's worth mastering the basics!

The basic color wheel is made up of the primary colors: red, yellow and blue. Primary colors can't be created by mixing any other colors (they *are* the basics), but with these three colors, you can create all the other colors of the rainbow.

For our purposes, I've included a warm and a cool version of each primary color. When you mix colors, it's a good idea to match the temperature. For example, a cool red and cool blue will combine to make a much nicer purple than you'd get with an warm red and a cool blue. Likewise, a cool blue mixes better with a cool yellow to make a nice, clean green, and a warm red and warm yellow make the purest orange, as on our color wheel.

Of course, in painting animals, most often you won't be using the pure primary and secondary colors, at least not exclusively. But you can create very subtle paintings using a subdued version of this color theory. Naples Yellow or Yellow Ochre can stand in for the yellow, Burnt Sienna can be your red and Payne's Gray can act as the blue; these hues are gorgeous together, and are often found in nature in larger amounts than the more pure versions. Mix and match to create a realistic effect.

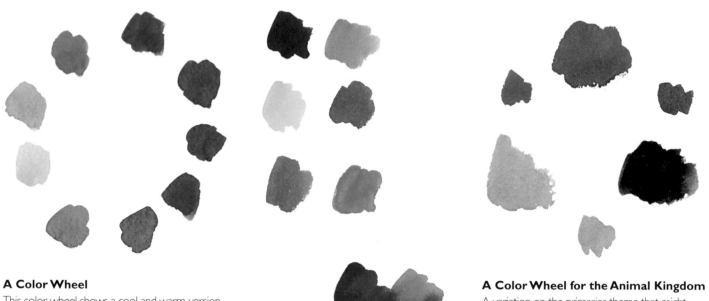

A Color Wheel
This color wheel shows a cool and warm version of each primary. Separating the primaries from each other are the secondary colors: green, orange and purple. Green is created by mixing yellow and blue, which is why it's placed between these two primaries. Likewise with orange (from red and yellow) and purple (from red and blue).

Go for the Complements
The complementary colors, that is! Colors opposite each other on the color wheel are known as complementary colors; green is the complement of red, purple is the complement of yellow and orange complements blue. You can use that knowledge to provide a vital, exciting vibration when you place complements next to each other in your painting. You can also mix complementary colors together to create a subtle gray. Let one color dominate the mixture, otherwise you'll get a plain gray—unless that's what you want!

A Color Wheel for the Animal Kingdom
A variation on the primaries theme that might look more believable in nature. Yellow Ochre, Burnt Sienna and Payne's Gray stand in for yellow, red and blue.

Loosening Up

If you feel intimidated by the idea of "making art," try loosening up a little. Use a child's box of crayons, if you like! If "wasting" good paper bothers you, practice on newsprint or the backs of used computer paper. This is just to get you loose and flowing, anyway; you're not going to rival Andrew Wyeth just yet! Get your whole hand and arm into the act, making big, sweeping motions. Stand up to do it, if you like. Tape your paper down so it doesn't move around with your sweeping movements.

Little kids don't worry too much about creating masterpieces. They just have fun, play and create. We can do the same. It's not necessary to try to make a realistic picture at first. Enjoy the feeling of the tool in your hand and the marks it makes on the paper. Explore these different marks: lines, spirals, shapes, dots.

Pencil

Technical pen

Dip pen

Colored pencil

Watercolor pencil

Learning the Movement
This is a good time to just make *marks*. Let yourself go. It's like dancing!

Spirals
Try spirals or coils, getting used to the feel of making these marks. Try making them uniformly, then varied.

Dots
Make dots. Make tiny, uniform ones. Make them close together and more widely spaced. Make big dots and little dots. Look at how you can use them to suggest shading.

Round watercolor brush

Flat brush (side and edge)

Dashes
Try dashes in a similar fashion and think about what they suggest to you. Insects over a field of grass, birds in the sky? Play with the length, direction or precision of these dashes, and let your imagination soar. Consider how you might use them in your drawings or paintings.

Lines With Different Mediums
Make a variety of lines using all the tools in your arsenal. Notice how different pencil lines are from those made with a brush. Try varying the pressure.

Getting Past White Paper

If blank paper bothers you (and you're not alone—it bothers a lot of people!), try preparing a bunch of sheets ahead of time without worrying about what will eventually go on them. Use them right away or set them aside; you may come up with something weeks or months later that's perfect for that particular no-longer-white paper.

The little squiggles and sketches here are only suggestions... do what you like!

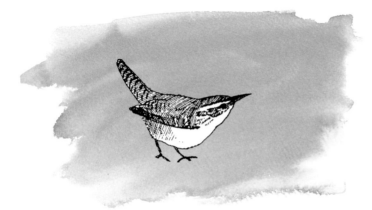

Change the Color of the Paper
An all-over, variegated green wash (see page 55) could form the background for a close-up of a bird in the grass or a landscape with cattle in the distance. The important thing is that you've started! It's no longer white paper.

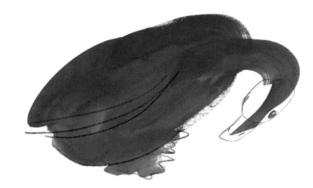

Bring Abstract Shapes to Life
If you want to play at a more abstract exercise, try something like a Rorschach test. Just splash a shape on that clean white paper, in watercolor or thinned-down acrylic, then let it dry. Go off and leave it alone. Later, it may suggest something to you: a prehistoric bird, a dragon, a butterfly or just an interesting background on which to draw something completely unrelated. This one reminded me of a red goose!

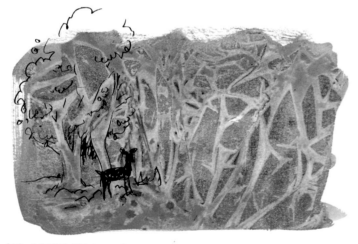

Work With Watercolor
Splash and spatter watercolor in a pleasing combination of colors, or lay a sheet of crumpled waxed paper, plastic wrap or aluminum foil in a wet wash. Pull it away when the paint's partially dry, or let it dry completely for more emphatic designs (this may take overnight). Then draw or paint what you like on the paper. It's no longer intimidating because it's not staring at you with that pristine surface. This one looks as though it could be trees in an autumn forest, so I thought adding the deer would be a nice touch.

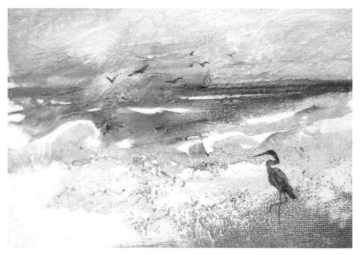

Play With Acrylic
Play with textures to get past that Fear of White Paper. Use acrylics to texture a background, then glaze it with colors. Again, let the result suggest what to do next. In this case, the paint looked like the line of foamy surf at the ocean's edge, so I added the proper colors and a fishing bird.

Sketching and Drawing

Now that you've gotten past the initial nervousness about that blank, white paper that threatens you with snow blindness (*brrr!*), you're ready to jump into some real sketching and drawing. In the next two chapters, you'll find some basic and time-tested techniques that will allow you to draw what you see.

These techniques are like musical scales—but a lot more fun to learn! They've been used in schools and workshops across the country. They've worked for grade school kids and octogenarians, so you know they'll work for you as well. More important, they'll lead you to your own style. And along the way, you'll find that you can have fun at what you're doing!

For these exercises, use simple, familiar tools that won't distract you or get in your way: a favorite pencil or ballpoint pen, and paper that's smooth enough to work on without snagging your point on the texture. I'm using a black fiber-tipped pen because it reproduces well, but use whatever you like best. Erasers are not needed for any of the techniques in this chapter because there will be no mistakes and nothing to correct.

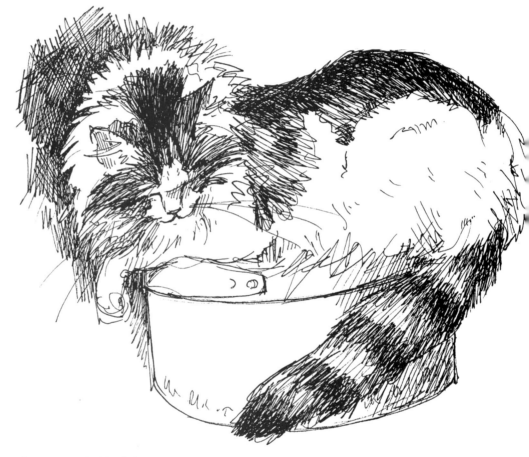

FUZZ ON THE GAME BOX
Pen and Ink
7" × 7" (18cm × 18cm)

Gesture Drawing

Gesture drawing helps you capture the gesture of your subject: the basic pose, the essence, the motion, the energy. This technique can be particularly useful when an animal is moving, but it's just as handy to sketch an animal at rest. I often use this technique when drawing one of my sleeping animals; it's great practice for honing that hand-eye coordination. If there's time, I can go back and add details, otherwise I move on to the next sketch. I have whole pages full of these little gesture sketches, and they're amazingly useful when I need to add an animal to a painting later.

Some artists I know warm up with gesture sketches before every session in their studio, like stretching before a run. As you keep at it, you'll find the lines becoming more and more accurate. I've seen framed drawings that were no more than this—no tight details needed!

MATERIALS

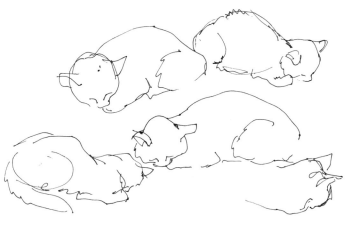

PAPER
80-lb. (170gsm) paper

OTHER
No. 2 pencil

1 Find a subject that's relatively still: your dozing pup, a horse cropping placidly in a field, a cat watching intently out the window. Have your sketchbook and pen or pencil handy.

2 Now, give yourself three to ten seconds (yes, that's right, *seconds*!) to get the pose down on paper. This isn't the time to worry about likeness or accuracy; just catch the basic shape in a few lines. Do as many sketches as you like (or have room for) on the page, overlapping if you need to. It's as much a loosening-up exercise as anything, but it's also marvelous, stress-free training. Obviously, you can't beat yourself up when you've only taken three seconds to do a drawing!

3 If you want—and if the critter's still in the same position—you can go back and concentrate on a detail or two: the paws, the nose or whatever.

WORDS TO KNOW

GESTURE A subject's gesture is more than the basic pose; it also means its essence and energy.

Catch Motion With Gesture Sketches

As well you know, animals move—sometimes very quickly. Don't let that discourage you. You're not a camera with a fast-speed shutter, you're a human being and an artist. What you're aiming for here is capturing the *essence* of your subject, not a completed painting! After practicing gesture sketches of an animal at rest, you'll be used to the kind of hand-eye coordination needed to catch the motion in three seconds or less, as well.

Using the same tools as before—a familiar sketching tool and your favorite drawing surface—try some gesture sketches of animals in motion. Again, go for the overall pose—the shape of the animal in motion. The ears can be nothing more than a pair of points or loops, the tail a simple linear swoop with a few squiggles to suggest fur. This isn't a portrait of your pet, but an exercise to help you capture motion. The fact that it's Scout or Sarah is incidental!

MATERIALS

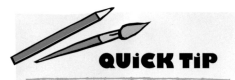

PAPER
80-lb. (170gsm) paper

OTHER
No. 2 pencil

QUICK TIP

REPEATED MOTION One interesting thing about animals is that they often repeat the same motion; it's part of their own unique dance. You can go back to your sketch when that particular motion comes around again.

1 Wait until you catch an animal in motion. Something with a nice repetitive action is good, like a cat taking a bath or your canary grooming. That way you won't feel so anxious about losing that particular pose.

2 Again, just catch the basic lines. Some people choose to sketch the line of the backbone, others the overall body shape. Try both, and then do what's most comfortable and satisfying for you. (I try to get as much of the animal's shape down as possible.)

3 Fill a page with sketches of the same critter, or several different ones. Over-

lap if you need to, but keep moving! Some drawings will hit the mark, some won't. So what? No one's grading your work, after all.

4 If you prefer, just do one sketch per page. Who knows? You might do one you like well enough to frame.

5 If you want, you can add details later, when your subject is again at rest; but for the purpose of gesture drawing, try to consider these quick studies as completed works. If that's too much of a stretch, then remember to look at them as practice exercises.

Catching the Energy

Motion isn't the only thing you can capture with gesture sketches. They allow you to get a sense of the energy contained in that moving body—the kinetic force, the life!

That life might be a bit too big to contain in your usual pocket sketchbook. Why not use a larger one, perhaps 16" × 20" (41cm × 51cm) or more, with a drawing tool that will encourage a more expansive motion? Try a large all-lead (solid pigment) colored pencil, a solid graphite stick, Conté crayon, pastel or a big calligraphy marker, for instance.

Stand up for this one. Use your whole body to draw: not just the hand and fingers, but your arm, shoulder and back as well. Try nice, big, loose, *fast* strokes. Fill the page with a single gesture sketch.

Some people like to work on a vertical surface for this type of drawing. Prop up your sketchbook on your painting easel or fasten a sheet of paper to the wall, and have at it!

QUICK TIP

LET YOUR ENERGY LOOSE
Let your energy loose to capture the feeling. Use your whole body when you draw, not just your hand and wrist.

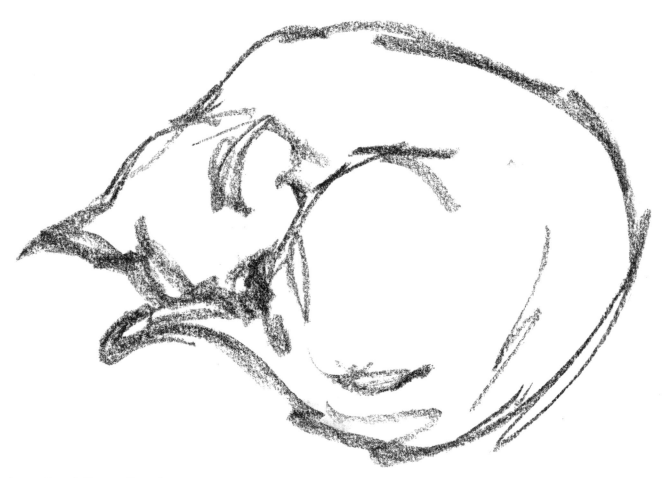

Large Conté Crayon Drawing
Why not go wild and use a brighter color for this one? Might as well tell your subconscious you're doing something really out of the norm. Who says a poodle can't be Cadmium Red, if that's what you want it to be?

Blind Contour Drawings

You may feel foolish doing blind contour drawings, but trust me, they're wonderful exercises in learning to see—and in letting yourself off the hook.

Put your paper on a desk or table (you may want to fasten it down so it won't slide around), then turn to look at your subject over your shoulder as you draw. You won't be able to see both the paper and your subject at once—that's why it's called *blind* contour drawing!

Sleeping models are best for blind contour drawings. You want to make sure your subject stays still for the length of time it will take you to complete your drawing—or as sure as you can be when drawing a live creature, anyway.

These drawings may be done much more slowly than the gesture sketches. You can take as long as you want, or as long as your subject remains in one position. Ten minutes is reasonable, but take as long as you like.

The neat thing about blind contour drawing is that you can't stress out about work you weren't even looking at. Almost *no one's* drawing will look a whole lot like the subject. (Feel free to laugh, because the results are often pretty funny!) The point is to pay attention to what you're seeing, and to get past expectations of yourself and your work.

MATERIALS

PAPER
80-lb. (170gsm) paper

OTHER
No. 2 pencil

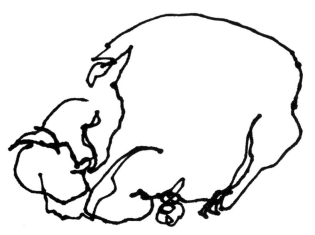

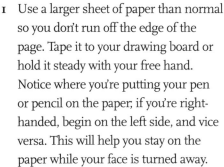

1 Use a larger sheet of paper than normal so you don't run off the edge of the page. Tape it to your drawing board or hold it steady with your free hand. Notice where you're putting your pen or pencil on the paper; if you're right-handed, begin on the left side, and vice versa. This will help you stay on the paper while your face is turned away.

2 Keeping your pencil or pen point on the paper, turn to look at your subject. Slowly follow the outside contour of its form. Pretend your pencil is an ant crawling along the contours, and keep going! Don't lift the point from the paper or you'll be hopelessly lost.

3 If you want to include details within the outer form—the nose, eyes, whatever—draw into the shape, then back out to the outside contour. Again, don't lift the point from the paper, and don't look!

4 Take your time. Pay attention to the shapes and textures that describe the contour of your subject: smooth muscles, long hairs, whatever catches your eye.

5 Keep going until you get back to your starting point (if you started with the nose, you should end up back there). Now you can turn and look at your paper. It will be amazing if your line finished anywhere close to your starting point. I've had only one student do that!

Modified Blind Contour Drawings

Modified contour drawing is just what it sounds like. Basically, you'll do the same kind of drawing you just did, paying careful attention to your subject and following the contour, but now you're going to allow yourself a quick look from time to time to get your bearings and correct your direction. You may modify your drawing as you go along, if you wish. Still no erasers needed; just correct the direction of your line or draw over the one you don't like.

Now you're much more likely to end up in the neighborhood of where you started out. Interestingly enough, this technique is very much like that of experienced professional artists; often they look as much at their subject as at their paper to really get the feel of what they're drawing.

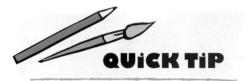

MATERIALS

PAPER
80-lb. (170gsm) paper

OTHER
No. 2 pencil

QUICK TIP

SKETCHPAD SUGGESTION
For this exercise, don't use a sketchpad with a ring-bound edge. It's uncomfortable and distracting to suddenly run into that wire while you're drawing, and you'll lose your mental focus.

1 As before, use a large sketch pad or piece of paper so you won't run out of room. Position yourself so you're turned away from your paper, but where you can peek from time to time.

2 Choose a convenient starting place. I often start with the nose or the top of the head. Draw without looking until you reach a spot where you change direction or where you think you might lose the thread; then, without lifting your pencil from the paper, take a quick look to confirm your bearings. Resume

drawing, taking this new information into account.

3 When you want to draw a detail inside the main contour, keep your pencil point on the paper and draw into the main shape. You can draw a lighter line, if you like, but keep the point in contact with the paper. After finishing your main subject, you can draw details around it, still using the modified blind-contour technique. Add the hooked rug your dog's sleeping on, or the cushions on the sofa.

Memory Sketches

Memory sketches are almost the exact opposite—in execution, anyway—of the contour drawing exercises you've just completed. Here, you look long and hard at your subject and then turn away to your drawing surface without looking at the subject again. This trains your mind to hold an image so that you can complete a sketch without your subject anywhere around.

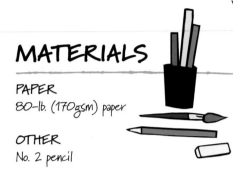

MATERIALS

PAPER
80-lb. (170gsm) paper

OTHER
No. 2 pencil

To fix the image in your mind, ask questions about what you see: What does that paw look like? How many of the pads are showing? How much of the ear can I see in that position? How big is the head in relation to the body? How long is the tail? Where's that back leg? What's he doing with his tail? How much do the eyes slant from this angle when he's sleeping?

You'll be surprised at how much you've retained from your careful observation. This exercise will help you many times in the future when you need to complete a drawing long after your subject has flown. If you've remembered to ask those questions, you'll be able to trust yourself with almost any subject. After a while, it will become second nature to ask the questions that help you see. Eventually, a model won't even be entirely necessary. You'll become familiar enough with the workings of a dog's hind leg or the shape of a horse's head to finish a credible sketch even if your subject is nowhere to be seen.

QUICK TiP

ASK QUESTIONS AND COMBINE TECHNIQUES Ask yourself questions and make mental comparisons so you can go back and catch the essence later. Most artists combine aspects of memory drawing with elements of modified contour drawing as they work. It's concrete creativity, and a great confidence builder!

1 Look at your subject as long as you can, and imagine yourself drawing it. Consider how you'll render each form. Let those questions you've asked fix the details in your mind. You can even write down the questions down if you like.

2 When you're ready, turn away from your subject and start drawing. Do as much as you can with what you remember easily. Pay attention to the image still fixed in your mind's eye.

3 If you reach a place where you're unsure how to continue, think of the questions you asked. Try to remember the answers, and draw some more. Trust your observations rather than relying on logic or cliché.

Using Geometric Forms

Many artists are happiest using geometric forms: combining ovals, circles, triangles, cylinders and so forth to create a foundation for their drawings. If the idea doesn't seem too mechanical to you, give it a try. Children often start out this way; look at how-to art books meant for kids. It's important to avoid the tendency to squeeze living beings into rigid, hard-edged forms. It's too easy to lose your subject's vitality by relying on geometric forms. If you can keep your shapes rather free-form, however, this approach may work well for you.

The advantage to this approach is that geometric forms simply what we see. They help us perceive where the forms overlap, giving us a sense of spatial relationships, and sometimes helping us to see volume as well as flat images. After all, if we're thinking in terms of a shape with volume—an egg rather than an oval, a ball instead of a circle, a cylinder rather than a rectangle—we're a long way toward suggesting a creature with roundness and volume.

MATERIALS

PAPER
80-lb. (170gsm) paper

OTHER
No. 2 pencil

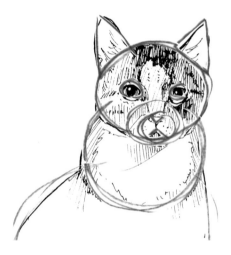

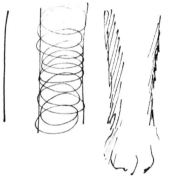

Overlapping Forms

Look at your subject closely to see what forms it suggests. Is the body an elongated oval? The head a rounder one? Does the dog's head resemble a ball with a longish cone for a snout? Do your cat's ears fit inside a pair of triangles? If it helps you to break down the shape of your pet down into these shapes, give it a shot.

Use this technique judiciously as a tool, not an end product. It's just the first step on the way to drawing accurately. Sketch in shapes lightly, as guidelines only, then draw your pet more boldly within the loose outline you've given yourself.

1. An animal's leg can be reduced to two lines, but it doesn't have much life that way—especially without the rest of the animal.

2. Try sketching in some circular spirals to suggest volume.

3. Now it should be easier to create a more realistic leg. Let the lines bend in a bit by the ankle. Sketch jagged lines to indicate fur and a few straight, parallel lines for shadows (remembering that sense of roundness). Add some curves for toes... and *voilà*!

QUICK TIP

CAUTION! If you're not careful, geometric shapes can blind you to what is actually there! Don't rely on them exclusively.

Drawing Negative Shapes

One of my students once objected to the use of the term "negative" shapes because he thought it was, well, so *negative*. But in this context, it only refers to the shapes that surround the ones you want to depict. It's like drawing the doughnut hole instead of the doughnut!

Sometimes we get hung up drawing what we think we know rather than what we see, so we overlook the subtleties of angle and curve and relationship that make our work look real. We "know" a cat's nose is a cute little triangle, and overlook how it sits in relation to the mouth or cheek. We "know" all four legs are the same length, really, so we don't see the effect of perspective. Looking at negative shapes helps break down that tendency. Paying attention to the space between an animal's legs helps you to get past common assumptions about the shape of the legs themselves so that you can draw much more accurately. Noticing the shape of the area between the nose and the eye helps you to draw both those forms better.

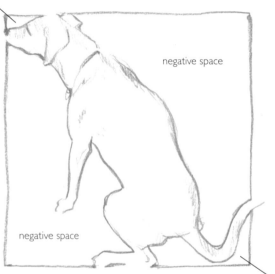

negative space

negative space

negative space

Negative Space
Drawing a box and then fitting your subject into it helps you to see the surrounding negative shapes more clearly so you can draw them more correctly.

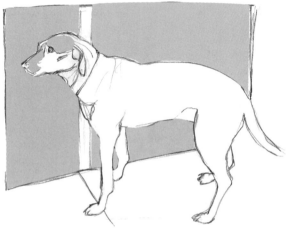

negative space

Negative Shapes on the Subject
Paying attention to the negative shapes on the subject itself sometimes helps us to see. A dog's legs are all the same length, but visually they become subject to the laws of perspective. Looking at the spaces between the legs helps to capture that reality. The shapes in the head and face are exaggerated to help you see them better, too.

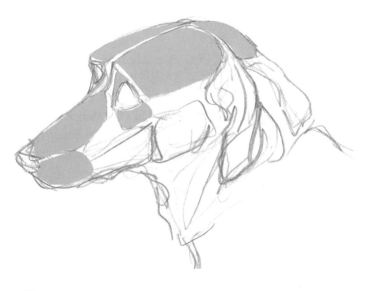

Using Negative Shapes to Place Features
Look at your subject's face. You see eyes, a nose and a mouth, right? Now pay attention to the negative shapes around those features.

In general, pay attention to the muscle masses, bones and other shapes surrounding the eyes, ears and nose. You'll find that you've placed them more accurately on the head.

Drawing Overlapped Forms

Pay attention to overlapping shapes. If you can see where the tail attaches to the body, but the animal is lying on the rest of it, make sure it comes out correctly on the other side!

Same thing with legs: If your subject is lying down, imagine the leg underneath. You can draw a light outline of where that part would be to help you follow through correctly and draw more accurately.

Connect the Dots

We're not talking about the old puzzles that used to be in kids' magazines, but a way to orient your subject on the page as you go along—without committing to anything you can't undo easily. You may find it helpful to make very light reference points, or dots, when sketching your composition. Don't worry about drawing your subject too emphatically at first; just make a dot here, then determine about how far the nose should be from the corner of the eye and make another dot. Make one where the eye ends, and one at the farthest point of the cheek, then where the ear begins, and where it ends. Put a dot or two at the top of the head, the point of the shoulder, the curve of the back, the root of the tail, the end of the tail... you get the idea. Then connect the dots, correcting where necessary, and flesh out your drawing—pun intended! (I've used red dots here so they're easy to see, but if you just make light dots in pencil, you won't feel that you've spoiled your good paper.)

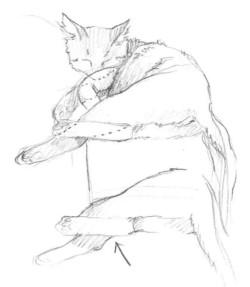

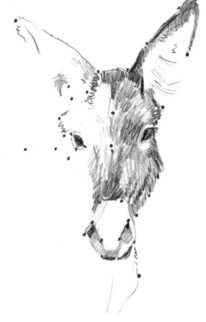

"See-Through" Animals
My cat Scout loves to lie on the computer, and she was kind enough to demonstrate those overlapping limbs for this illustration! If you draw a dashed line—in your mind or on your paper—to continue the line of a leg or other body part, you're more likely to draw its position accurately. The example above shows what happens if you don't clearly observe overlapped forms: It looks like that lower foot belongs to another animal!

Orienting Dots
I exaggerated the dots that act almost as a shadow map here by using a red fiber-tip pen so they'd show up in the illustration. When you draw your orienting dots, use a very light touch with graphite pencil. That way, the dots can be erased, drawn over entirely or even ignored.

QUICK TIP

DRAWING "SEE-THROUGH" FORMS This can be especially useful if you're drawing two or more animals together. Keeping track of what belongs to which animal is simpler if you imagine that your subjects are see-through.

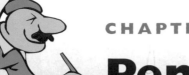

Pencil Drawing Step by Step

Pencils are about the most basic, nonthreatening art tool you could ever hope to use. We reach for pencils to take phone messages or write grocery lists, so we're as familiar with them as we're likely to get. They're also inexpensive, easy to find, forgiving, versatile and capable of both great subtlety and amazing boldness. What more could you ask for?

You can keep it very simple indeed—a no. 2 pencil and a sketch pad—or you can branch out into all sorts of wonderful, exotic sketching tools. You can buy pencils with all degrees of hardness for a variety of effects. You can purchase graphite sticks or carpenter's pencils, an array of sharpeners and erasers, maybe even some blending tools like tortillions or stumps. You can use an eraser guard to make even that step precisely controllable.

With this much versatility, you can make everything from quick, loose sketches to graphite drawings that rival a photograph. It's all up to you.

BODINE
Graphite
6" × 7½" (15cm × 19cm)

Pencil Drawing Materials

The equipment list below is pretty extensive. If you like, you could get by with just the no. 2 pencil and something to draw on, but the other items below will let you explore graphite thoroughly.

Recommended Equipment for Pencil Drawing

- **A common no. 2 pencil.** Pick these up at an office supply, discount or art supply store.
- **Several drawing pencils in a range of hardnesses.** It's not necessary to purchase the whole range from 6B to 9H; just buy enough to give you an idea of what's possible and what works best for you. Berol has a variety of wonderful pencils, But I have other old favorites, like Derwent, General, Faber-Castell, Koh-I-Noor and Staedtler Mars Lumograph. If you draw much with pencil, you'll find the ones you like best.

- **Stick graphite.** There are several brands of these, but Koh-I-Noor is my favorite. A woodless pencil is just that—all graphite with a painted coating to keep your fingers clean. It's great fun and very bold to use.
- **A flat-lead carpenter's pencil or sketching pencil.** General makes a nice range of leads.
- **A water-soluble pencil.** If you'd like to play with lines and washes, this is a wonderful tool.
- **A sample range of drawing papers.** Start out with some rough, some medium, some smooth.
- **A stump or tortillion.** These are rolled paper tubes used for blending. Stumps are larger than a crayon; tortillions are about the size of a pencil.
- **A kneaded eraser.** These are great for lifting areas of tone.

- **A soft vinyl eraser.** If you really, really want to buy an eraser for actual erasing, get one of the soft white vinyl ones. Staedtler Mars makes a good one. Clean your eraser often on a piece of scrap paper (or your jeans) so it doesn't smear the graphite.
- **An eraser guard.** For lifting shapes.

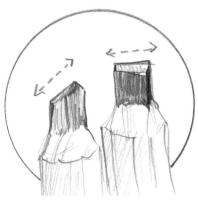

Carpenter's Pencils
You can sharpen carpenter pencils in two ways—straight across or at an angle—for a variety of sketching possibilities.

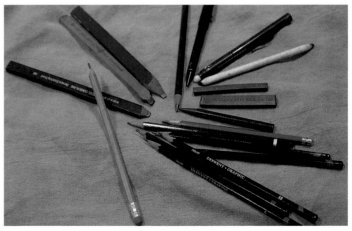

Drawing Tools
Going clockwise from the no. 2 office pencil at lower left, three flat carpenter's pencils, General's Sketch & Wash pencil no. 588, a mechanical pencil (needs no sharpening!), a mechanical white vinyl eraser, a rolled paper stump for blending, a square and a rectangular graphite stick, a "woodless" drawing pencil, and a group of five drawing pencils of various hardnesses.

An Eraser Guard
Consider getting an eraser guard or shield at the art supply store. With this, you can zero in on any tiny shapes cut in the metal template without smearing the rest of your drawing. Naturally, these are only for more complex drawings!

Getting to Know Graphite

As you probably know, lead pencils aren't really lead, even though we talk about sharpening the lead or breaking the lead. Just goes to show how contrary we are—it's graphite in that pencil! I'm glad of it, too, since lead is poisonous (and I chew my pencils).

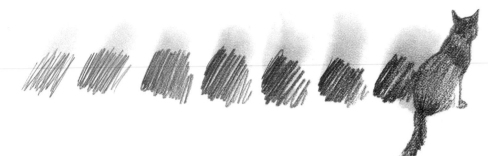

Hardness

Drawing pencils for artists range from 6B, which is quite soft and makes a thunderous dark that blends, lifts and smears easily, to 9H, which is quite hard and makes a light, precise line, though it's difficult to blend since it smears very little. If you want light, delicate, controlled, silvery lines, choose one of the harder leads. If you want drama, go for one of the softer leads. It's the ratio of clay to graphite that controls the degree of hardness: The more graphite, the softer the lead.

Range of Pencil Hardnesses
HB is the equivalent of a good, old no. 2 school pencil. The H stands for hard; the B doesn't stand for soft, but is anyway. There's also an F, which is similar in hardness to the HB, but has a slightly different tone (I have no clue where that letter came from!).

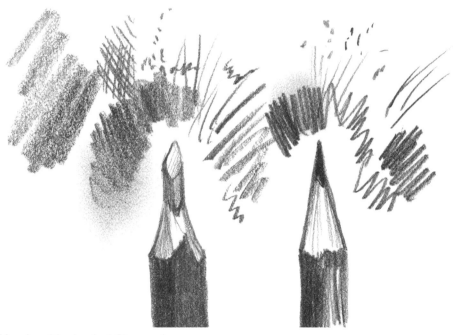

Sharpening

For field work you may prefer to take along a pocket sharpener from an art supply or local discount store. You could even use a mechanical pencil that doesn't need sharpening. But for most sketching and drawing, you can sharpen your pencils very successfully with a pocketknife or razor knife. Use your blade carefully; you want to expose the lead, not break it off by using too much force. You may find that bracing your thumb against the back of the blade (the dull side) allows you to have the greatest control. Finish sharpening the tip in a wedge shape on fine sandpaper. The wedge shape is extremely versatile; you can use the point, the flat and the edge for a variety of effects from a single tool. A pencil sharpened this way is actually less likely to break at the tip.

Hand vs. Mechanical Sharpening
The hand-sharpened pencil is on the left; the mechanically sharpened pencil is on the right. Notice the difference between the textures of their marks. The wedge-shaped pencil on the left is far more versatile.

Making Your Mark

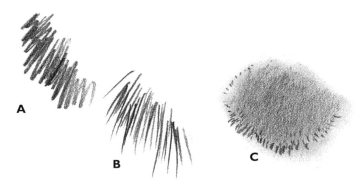

The Many Marks You Make

Practice making all kinds of marks: squiggles, zigzags, crosshatching, dots, areas of tone as smooth as you can make them. Have fun!

A

B

C

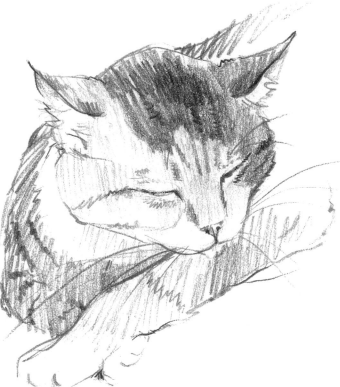

Simulating Fur

You can achieve a furlike effect with pencil lines in a number of ways. Try these out to see which you prefer:

A. Make rough "fur" lines with bold squiggles. This is fast and sketchy but can be very effective.

B. Let each pencil stroke suggest a single hair. Lift as you reach the end of the stroke so it has a tapered effect.

C. Try making a soft graphite tone, blending it with a fingertip if you like, then adding "guard hairs" with a sharp pencil point.

QUICK TIP

HOLDING YOUR PENCIL How you hold your pencil makes a big difference in the kind of marks you make. If you grip it as if you're writing a note to Aunt Hortense, you'll get one kind of mark. If you hold it more loosely, from the side rather than in your fist, you'll get a looser, freer line.

Beyond the Basics

There are all kinds of wonderful things to draw with: carpenter's pencils, stick graphite and even graphite pencils that turn to lovely tonal washes when you brush them with clear water. Try these out and see what they will do.

Blending

Use your finger to smooth and blend graphite. This is especially effective if you've chosen one of the softer leads. Stumps and tortillions are for more controlled blending in smaller areas. You can also lift highlights with a kneaded eraser or eraser and masking fluid (see the demonstration on page 37).

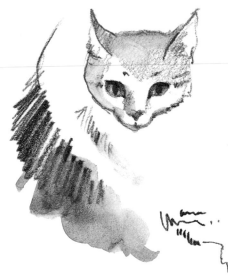

Stick Graphite Effects
Stick graphite can be extremely versatile. The shape allows you to work with a tiny corner, an edge or the entire side of the stick.

Graphite Wash Effects
Water-soluble graphite is wonderfully versatile. You can make pale, subtle washes by putting on only a thin layer of graphite, then softening it with water. If you prefer, lay down a bold area and discover how dark it remains when wet. For dark accents, you can wet the tip of your pencil and go back in to add the darkest values, as I did in the pupils of this little cat's eyes.

Blending
Whether you use a tortillion or your finger, it's your choice. Each gives a different effect, from soft and broad to quite controlled.

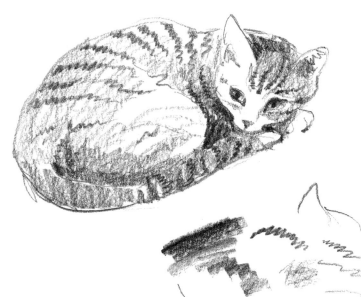

Flat Sketching Pencils
Flat sketching pencils are capable of a variety of strokes, tones, and lines. Here, I've shown a variety of possibilities, but these are only suggestions.

Getting It Down on Paper

Your paper's surface will affect your pencil's effects. Try making marks on several types of paper to see the differences. Paper with a bit of texture is said to have "tooth." If the paper has a *lot* of tooth—that is, emphatic miniature hills and valleys—the graphite will sit mostly on the top of the hills, but not get into the valleys, depending on how hard you press and how you hold your pencil. This can make a nice sparkly or rough texture; but if you're going for smooth skin tones, it might be a bit frustrating.

See what a medium-tooth surface will do, and then a very smooth one, like vellum. I sometimes do portraits on smooth paper because it's easy to blend on that surface, and fairly easy to (*shhh!*) erase if I need to.

2B on Rough Paper

2B on Smooth Paper

2B on Vellum paper

2B on Canvas Paper

QUICK TIP

IN THE THICK OF IT Even for pencil drawing, I prefer at least 2-ply or 80-lb. (170gsm) paper. Even though I'm not using a water-based medium, the thicker paper will resist folding or tearing.

Making a Graphite Pencil Drawing

First, of course, decide on your subject. When I found that my cat Bodine had gotten the cabinet door open overnight and found himself a private place to sleep among the cups and glasses, it was just too funny—and endearing—not to record in my sketchbook.

MATERIALS

SURFACE
A smooth, heavy paper, such as Strathmore vellum

PENCILS
HB pencil • 2B pencil • 4B pencil

OTHER
Tortillion or stump • Kneaded eraser • Tracing paper (optional) • Workable fixative

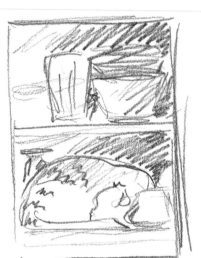
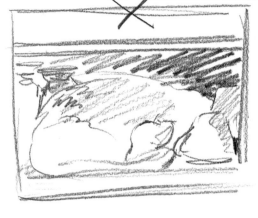

1 Before you turn your original quick sketch into a more finished drawing, decide on a format: Would a vertical format be more effective for your subject, or a horizontal? I chose the horizontal, since that's how Bodine himself was oriented. Then decide what needs to be included and what doesn't. I edited out the additional shelf above him. A more extreme horizontal could go well with this subject, too.

Sketch some possibilities. They can be tiny thumbnail sketches no bigger than your thumbnail, if you like. Don't let your composition get too static; break out of the box a little. I decided to let the tail droop down below the shelf to break up the rectangular frame.

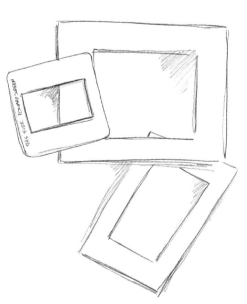

Use a Viewfinder
It isn't absolutely necessary to sketch possible formats. Instead, you can use a viewfinder. Use an empty slide mount or a rectangle cut into a piece of cardboard as a viewfinder to help you settle on a format. If you cut your own viewfinders, try making one with more extreme proportions as well as the classical ones. Cut a rectangular hole that's longer on one side of the rectangle than the other, (such as the bottom one shown here), so you can check the suitability of different types of formats.

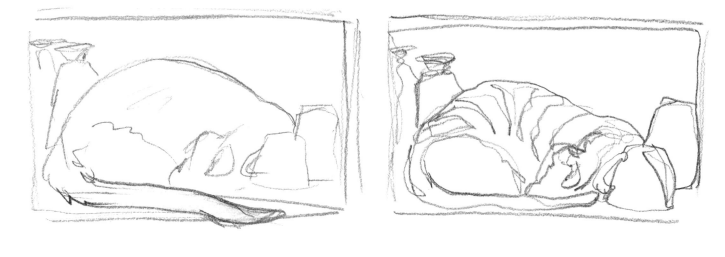

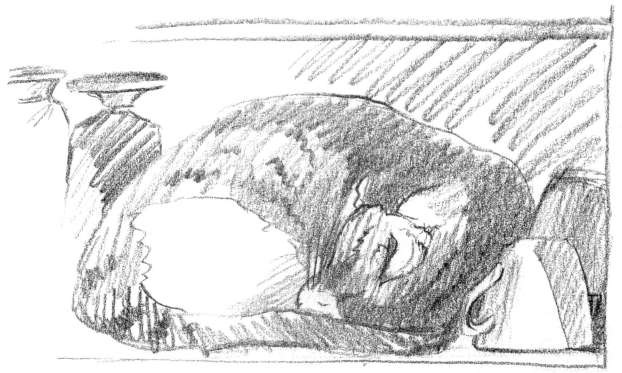

2 Now, consider which technique would be most effective for your subject, and make some more experimental sketches. Explore the possibilities with a clean, simple outline, a modified contour drawing with lively lines, or a tonal sketch like my original. (You can tell I liked that best.)

QUICK TIP

NEGATIVE SHAPES When drawing an unusual pose, pay attention to the negative shapes (the shapes around the animal) as well as the positive ones. Doing so will help you draw unusual forms more accurately.

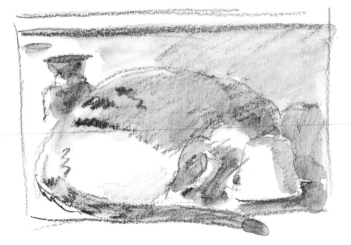

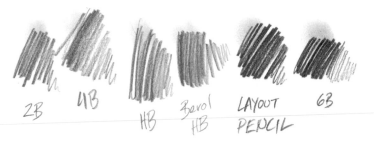

2B 4B HB Berol HB LAYOUT PENCIL 6B

3 Help yourself decide which pencils to choose by making a few samples. See what blends well—a quick rub with your forefinger will tell you.

Experiment with the new water-soluble pencils, too. Try a variety of techniques to familiarize yourself with this unusual medium. Wet the pencil first, then shade in your drawing, making sure there is a variety of values. Wet the paper all at once to make a light all-over tone. Once this is dry, dampen everything again, then draw some darker lines and markings with your water-soluble pencil.

See how this works with your basic composition. I liked the silvery quality, but decided to stick with a simpler technique.

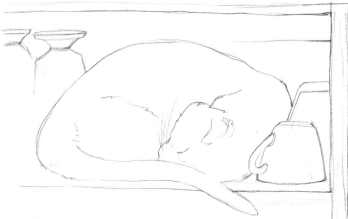

QUICK TIP

AVOID SMEARING Keep a clean sheet of paper under your drawing hand to prevent smearing. If you're right-handed, work from left to right; if you're left-handed, just the opposite.

4 Now that you've decided where you're going, transfer your sketch to the vellum drawing paper. Do this by eye, very lightly, with the HB pencil. Or, if you would feel more comfortable, do your initial drawing to size on tracing paper and transfer that lightly to your drawing paper.

It's possible to use a grid to transfer, but grid lines are difficult to erase with this medium.

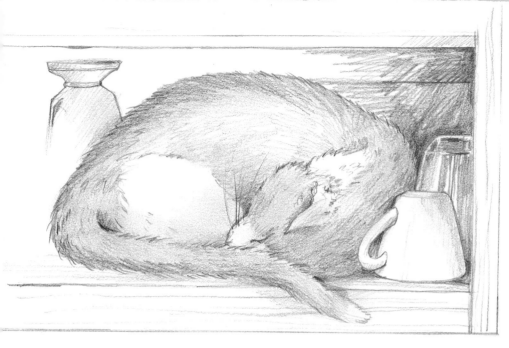

5 Begin with the light and medium values; it's easier to darken an area that is too light than erase areas that are too dark. Work smoothly with the wedge of your pencil's point, allowing your strokes to follow the direction of hair growth in some places. No need to hurry! Blend the graphite with your finger here and there to suggest volume, as on the white fur of the chin and back leg.

BODINE
Graphite
6" × 7½" (15cm × 19cm)

6 Finish with the darkest values and details such as the cat's markings and eye. Use a sharp pencil to suggest individual dark guard hairs and markings; a 4B works well. You can lift areas that may be too dark or have smeared with a kneaded eraser, but be sure to turn it (knead it, hence the name) often so you don't redeposit graphite where you don't want to. Don't rub; just pick up excess graphite by pressing and lifting.

Graphite will smear (that's its major drawback), so if you want to keep a pencil drawing, finish it with a light spray of fixative such as Kamar Varnish by Krylon.

I confess that I prefer my original sketch, for its strength, energy and immediacy! If you like yours, nobody says you have to carry it through to a more completed form.

Pen and Ink Step by Step

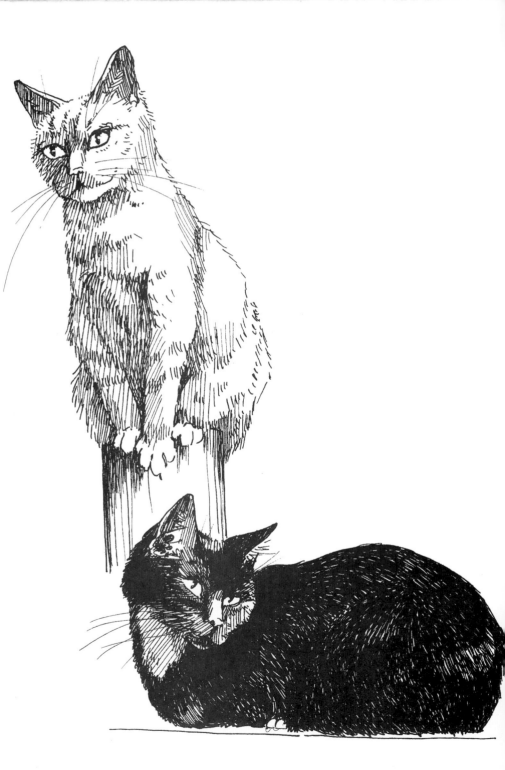

Ink is a more emphatic and permanent medium than pencil, and as such some artists avoid it. An ink line is pretty much there to stay, without some aggressive methods to remove it. However, it is also clean, crisp and versatile. Ink can be delicate and precise or boldly abstract, wildly complex or simple as a hard-boiled egg. It can be black as midnight, or brilliantly colored.

Ink drawings of animals can be very effective, and the medium is particularly well suited to some styles. Repeated lines suggest fur nicely, especially if you lift quickly at the end of each stroke. Solid, bold areas of ink work well to suggest a black animal, or you can closely space your strokes to follow the direction of hair growth.

You can try a variety of applications. To suggest form or to capture detail, you could use straightforward lines, combine lines and tone, or try stippling, hatching or crosshatching.

WESTPORT AND REUBEN
Ink Drawing
11" × 8½" (28cm × 22cm)

Pen-and-Ink Drawing Materials

There are many choices with this medium. You may want a dip pen and liquid ink, or a fiber-tipped pen, or an Oriental brush pen, or even a ballpoint for subtle, silvery effects. There is a wide variety of tools and techniques to explore. In this chapter we'll look at a few of the possibilities.

Recommended Equipment for Pen-and-Ink Drawing

- **Pigma Micron pens in a variety of sizes (at least .01 and .03).** These pens come in various colors.
- **An inexpensive ballpoint pen in black.**
- **Inexpensive fiber-tipped pens.** One with permanent ink and the other with nonpermanent ink.
- **Brush pen.** Available in Asian art supply stores or the calligraphy section.
- **A crow quill.** Or other dip pen with a fine point.
- **An inexpensive round watercolor brush.** A no. 5 or smaller.
- **India ink.**
- **Other inks as desired.** There is a great variety of water-soluble, opaque and transparent inks in many colors—even metallic.

If you're reluctant to jump right in and put ink to paper, you can sketch our guidelines with a pencil first. Once the ink is thoroughly dry, erase any remaining pencil lines. (Or leave them where they are; they often provide an interesting vibration.) Give yourself permission to restate lines if necessary, to be more accurate so you won't worry about getting one down "wrong."

Pigma Micron Pen (.01) Drawing
Notice the difference between this drawing and the one on the previous page. Both were drawn with Pigma Micron pens of the same size, but this one was drawn with an older pen that was slightly dried out. I like the delicate, airy lines it made.

Sharpie Drawing
Sometimes it's good to use an inexpensive tool just for practice. Choose a pen from an office supply or discount store, or even a grocery store. Permanent markers such as Sanford's Sharpie make good, bold drawing tools.

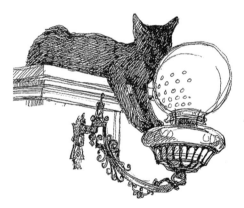

Pilot Ultra Fine Drawing
A finer pen is wonderful for capturing details. This ornate Victorian lamp would have been difficult to draw with a clunkier pen, but a Pilot Ultra Fine worked just right. The pose, with Pooh warming his nose against the lamp, was just too good not to draw!

Where your subject is rather complex, it's best to rough in the animal's overall pose first, in case it moves. The lamp, of course, is going to stay where it is. You can develop the details of the kinetic kitty later, if you like.

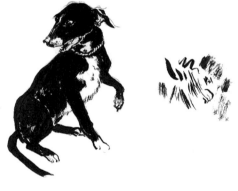

Ink Brush Drawing
This ink drawing—more of a painting, really—worked well for this young black dog named Jake. It can be tedious to fill in dark areas with a small pen, but a brush and a bottle of India ink make short work of the matter. Keep things bold and relatively simple when using a brush; let the lively calligraphic effect carry the drawing.

Getting to Know Pen and Ink

Ink is an amazingly versatile medium. It's also venerable; artists, calligraphers and scribes have used ink for thousands of years. Why not explore the possibilities—including the modern fiber-tipped and technical pens—for yourself?

Pens

Gather a variety of ink-drawing tools, including some with a built-in ink reservoir (such as some fiber-tipped, ballpoint or fountain pens), and an old-fashioned dip pen and ink. You may want to try a very fine crow quill pen, available at most art or craft supply stores, or something a bit larger. A brush pen can be a fun and expressive tool to try as well.

Once you've found a good selection of pens, put them through their paces to see what they can do and what effects you can achieve with them. Make repeated straight, parallel lines, called *hatching*, and then go back over them in another direction to make a darker area; that's called *crosshatching*. Make stippling dots and squiggles, just to see how the pen handles. Then try it out on the animal of your choice.

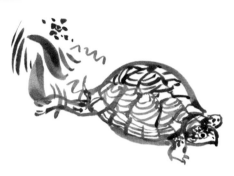

Brush Drawing With Sepia Ink

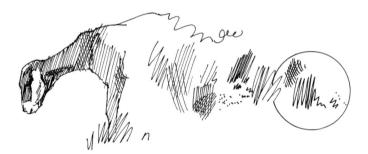

Pigma Micron .01 and .03

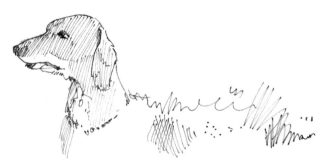

Pilot Ultra Fine

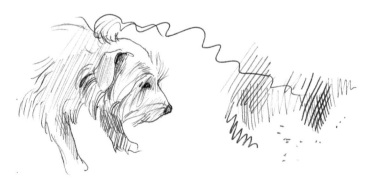

Bic Black Ballpoint

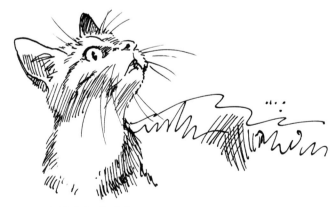

Dip Pen With India Ink

The Dip Pen

The dip pen is one of the more traditional tools to use with ink. Using a dip pen is not difficult, it just requires finding a nib to match your needs and learning a few simple tricks.

Dip only the nib into the bottle, not the handle (or you'll get your fingers all inky!), and then tap the pen against the ink bottle to get rid of the excess ink. Test the pen before you touch it to your drawing. When you're all through, rinse the nib and dry it on a paper towel; it will last longer that way.

Brushes

It's not necessary to use a pen, of course; you can also apply ink with a brush. Again, don't dip too deeply into the ink bottle and always test the brush on a piece of paper first. Wash the ink out quickly, or it will ruin the brush—this is no place for a good sable brush!

Inks

Inks come in a variety of colors and consistencies. While black is the traditional—and still most popular—color, there's quite a range to try. Some inks are waterproof when thoroughly dry. Others will spread when they are re-wet. Both have their advantages, so test out both types.

Though waterproof ink is permanent when dry, you can thin it with water to create a halftone effect. I like to apply this with a brush.

WORDS TO KNOW

NIB This is the tip of the pen, usually made of metal, though sometimes goose quill or bamboo. The shape and size of the nib determine the shape and size of the line. Most art stores carry a wide variety of nibs for lettering artists.

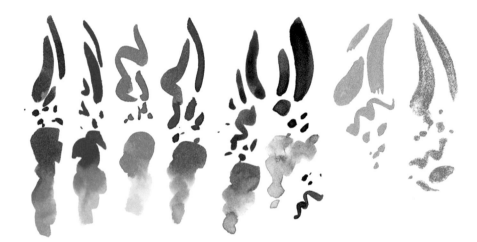

Colored Ink
Starting from the left, there are four water-soluble calligraphy inks, two artist's acrylic inks and even a silver and gold! I've applied all these samples with a brush.

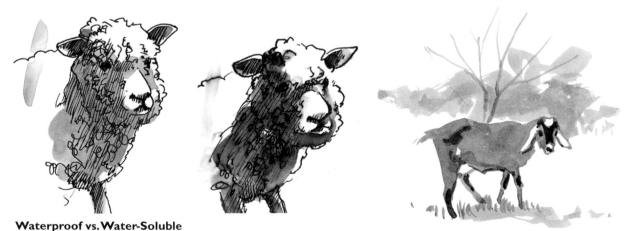

Waterproof vs. Water-Soluble
The waterproof ink on the left works well with watercolor paints. The water-soluble ink on the right can be applied and then wetted later if you decide to adjust the tone.

Halftone
Even waterproof ink can be thinned before it dries, for a halftone effect.

Pen-and-Ink Drawing

Start where you are most comfortable. I often work from left to right, particularly when working with ink. Play with your pen to see what kinds of strokes work best for fur; repeated strokes or zigzags in combination look right to me. Some people use the pointillist technique called *stippling*, making thousands of tiny dots to build up form, detail and volume. That requires a great deal of time and patience—not my long suit! I chose the more linear technique that works well for beginners and old hands alike.

MATERIALS

PAPER
Vellum 2-ply paper

PENS
Micron Pigma .01 and .03

OTHER
No. 2 pencil

Thumbnail Sketch
Do a tiny preliminary sketch to decide where you want to place the darkest darks and lightest lights. It's easier to do this in pencil than pen and ink. Keep it quite small, no larger than 2" × 2" (5cm × 5cm). It's a good tool for planning.

1 Pick your subject and make a rough pencil sketch of your composition. You can use a less expensive paper for the sketch, if you want, or do it right on the paper you plan to use as the final ink drawing. This planning stage can be as rough or as complete as you like; since you'll draw over and then erase the pencil guidelines, you may choose to make them very simple.

It is possible, of course, simply to start drawing in ink right on your art paper, with no pencil guidelines at all. If you're confident enough, go for it! That's how I work in my sketch journal, but accuracy there is not as important as the act of drawing itself.

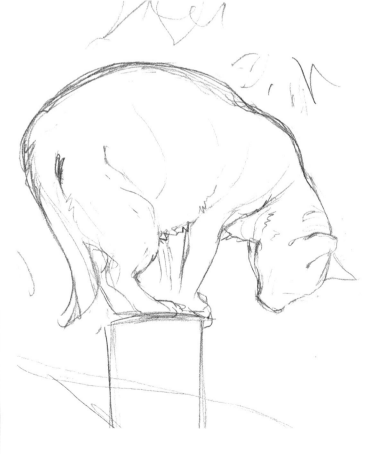

QUICK TiP

TRANSFERRING A DRAWING
There are a number of ways of transferring a sketch, but I like to trace my original drawing by placing my art paper over the sketch with a light behind both. You can use a light box or simply hold the two layers up to a window. Taping the two sheets of paper together ensures that they won't slip out of register.

2 Unless you want to jump right in with the ink, now is the time to place the bones of your image with pencil. Make any necessary corrections before you add ink. It's a lot easier to erase a light pencil line than it is to fix ink!

When you begin inking, build up your textures, forms and values first. Use expressive lines, hatching or crosshatching where needed. Switch to a larger pen, such as a .03 Pigma Micron, here and there to add a bit of variety, but use it sparingly. I used it on the left side of the forms to emphasize shadows.

Add interest by spacing your lines closely for the darkest areas, and crosshatching the midtones. Remember, a wide variety of values adds interest, but allow one value to dominate. Use these tricks to suggest volume as well as value.

Let some of your strokes follow the the direction of hair, particularly if the animal has stripes or spots you want to suggest.

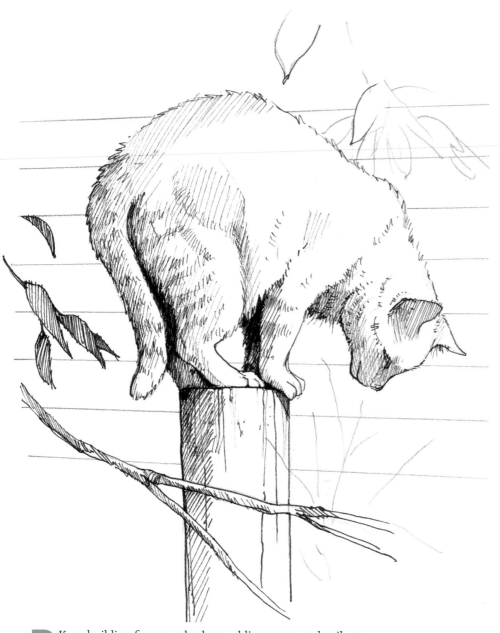

QUICK TIP

DEPTH IN YOUR DRAWING
Overlapping forms can give your draw-ing depth. Here, the foreground limb appears to be in front of the fence post, the dark leaves and siding behind the cat.

3 Keep building forms and values, adding as many details as you like. Give yourself some loose guidelines here for leaves, weeds and siding.

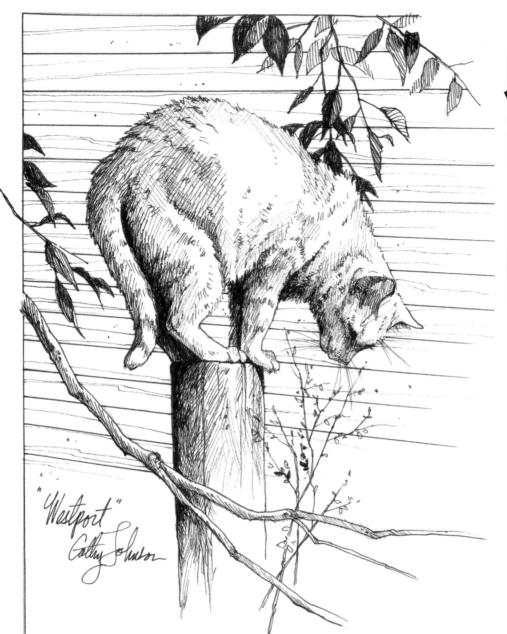

"Westport"
Cathy Johnson

4 Notice how the shadowy stripes on the cat's tail, foreleg and back follow the roundness of the body. These have been simplified in the sketch. Use zigzag or repeated parallel strokes to suggest the characteristics of this fur.

The darkest darks can be added more easily with a thicker pen, such as the Pigma Micron .03 or .05. Switching to a different type of pen, or a brush and ink, would be faster, but it would change the quality and color of the drawing slightly. This is fine for photoreproduction, but not so good for a drawing you might want to frame. Closely repeat lines or simply scribble, as I've done on the left side of the fence post.

If you have a slightly dried-out .01 pen, you can use it for finer, more delicate details such as the whiskers and grain line in the wood siding.

WESTPORT PREPARING TO LEAP
Pen and Ink
8" × 5½" (20cm × 14cm)

Colored Pencil Step by Step

There comes a time when you just need color to express what you're feeling or to capture your subject. If you're already comfortable with drawing or you don't have time for the extra equipment—or the mess—of painting, colored pencils are a marvelous solution. Quick, clean, affordable, colorful and familiar, they're also extremely versatile. You may decide to sketch your subject with a single bright hue if you like, or you can layer until the finished piece looks more like a painting than a drawing. You can buy a whole rainbow of pencils so you can choose just the hue you want, or you can lay in tints or shades next to one another to make a visual vibration that creates the illusion of a third color. Finally, you can put one color over another to modify and tone it. Some artists even blend the colored-pencil layers together with a liquid solvent, but that may be the subject of another, more specialized book. Let me introduce you to the basics of using colored pencil.

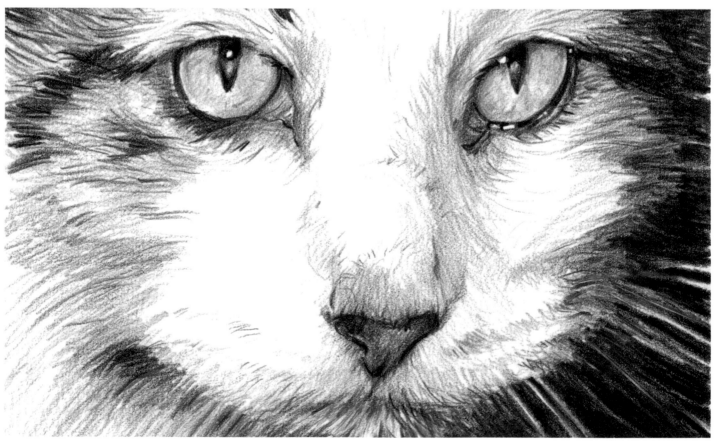

FUZZ
Colored Pencil
4" × 6" (10cm × 15cm)

Colored Pencil Materials

If you want, start with only a few pencils from open stock, either in a single color or two, or in the primaries (red, yellow and blue—perhaps a warm and a cool of each), plus black and white. It's amazing how much color you can get into your work with just these. If you like this medium, jump in and buy a whole set. My favorite brand is Prismacolor, but there are other wonderful brands on the market. Some are softer, some harder, some delicate and some more pigment-dense. Test each brand to see how you like the feel of the lead.

One of the lovely things about this medium is that it requires a minimum of equipment for a very big color impact. It's ideal for travel, requiring no water, turpentine or other medium and virtual-ly no cleanup except for putting away your "toys" when you're done. I even keep a selection of colored pencils in my car so I can draw any time I have a moment. No worries about them melting in summer or freezing in winter, either. Colored pencils are made from pure pigment in a wax base, and the wax is hard enough that it doesn't get squishy or brittle in weather extremes.

Recommended Equipment for Colored-Pencil Drawing

- **A selection of colored pencils.** Try several brands to see which feels best to you. Try some of the large "all lead" pencils or colored "pencil blocks" for broad coverage, too.

- **A selection of watercolor pencils,** if you want to play with a slightly different effect. There's more on this medium in the following chapter.

- **Two or three types of drawing paper.** You can try rough, medium, and smooth surfaces, but the latter two will probably prove most satisfactory.

- **A pink eraser** will remove some "mistakes" if you feel you really need to.

- **A single-edge razor blade or craft knife** works well for making marks or removing pigment, and also for sharpening the pencils.

- **An electric or hand-operated pencil sharpener.** I find the electric pencil sharpeners work better.

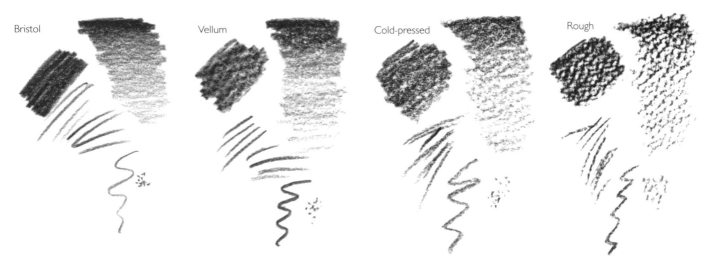

Bristol Vellum Cold-pressed Rough

Testing Papers
Test your colored pencils on a variety of papers to see which you prefer for the particular effect you want. Create areas of flat, smooth color using uniform pressure, as well as gradated tones by using lighter and lighter pressure. Make dots, lines and squiggles, too. You get very smooth, controlled effects on smooth bristol paper; a more open, sparkly effect on vellum and cold-pressed papers; and a very energetic, broken effect on rough paper.

Getting to Know Colored Pencil

Colored pencils are a happy marriage of pure pigment and wax that allows you to do everything from quick scribbly sketches to completed drawings that might be better called paintings. It's all in the application.

Colored pencils are quick, immediate, portable and clean. No need to carry water or other mediums, no need for brushes or other painting gear. They *do* work best with an electric pencil sharpener, which seems less likely to break the lead than a hand-operated sharpener, so you might want to look for a portable sharpener equipped with batteries. If you buy open-stock pencils rather than a set, look to see if the lead is centered in the wood casing. They're much less likely to break when sharpening if the lead is centered.

Like graphite pencils, colored pencils come in "all lead" versions. These have no wood casing, just pure pigment/wax covered with paint or varnish to keep your fingers clean. These are marvelous broader effects. You can buy crayons or sticks with the same basic formula if you want to work bolder still.

There is a huge range of available colors, from the subtlest of grays to the brightest of primaries. You can layer them for more color combinations yet! Use only a few colors or all the ones in your pencil box. It's up to you.

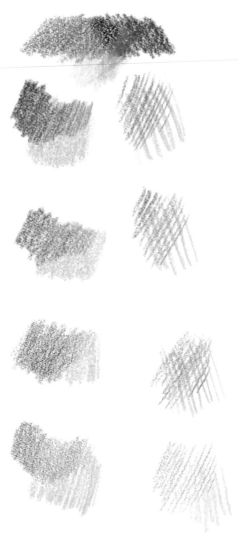

Layering Color
Experiment with layering colors to get the exact shade you want. See how few colors you can really get by with. Compare smoothly gradated applications (left) and crosshatching (right).

BLOOM Be aware that thick, heavy applications of color, particularly the darker hues, can "bloom," or develop a whitish haze on the surface. To prevent this, wipe the surface carefully with a soft cloth. You might also want to seal the drawing with a fixative, meant for pastel or soft graphite works.

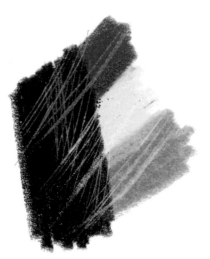

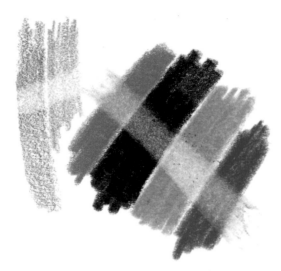

Scratching Through Color

You can do a heavy application of a color, cover it with a layer of black, then scratch through for fine details. This works best with the softer, richer, more pigment-dense pencils.

Erasing Color

It's not impossible to erase all the way to the white paper, just difficult. Still, you can lift a surprising amount. Just be careful not to abrade the paper too much, as shown in this sample.

Scraping Color

Sometimes you can simply scrape through the color to get to the paper tone beneath.

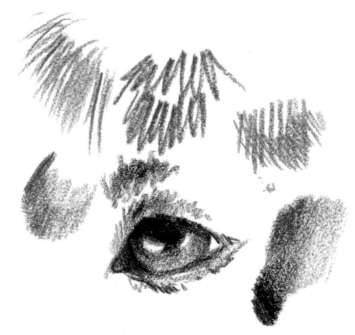

Limiting Color

You can get a surprising variety of effects with just a single pencil or two. Try out the tools to see what they can do. Here, hairlike strokes are created by lifting the pencil at the end to make finer, sharper points. Bold zigzags, cross-hatching and softly blended and carefully applied areas create a believable effect in this eye.

Colored Pencil Drawing

This is my sweet old cat Fuzz, who came to me one night in the middle of a blizzard. He was so sweet and good-natured I just knew he had to belong to someone. Dutifully, I put an ad in the paper and waited... but apparently he belonged to *me*. He's been here over fourteen years, and has been my model on countless occasions. I figured he wouldn't mind one more session.

MATERIALS

PAPER
Smooth bristol paper
Tracing paper

COLORED PENCILS
Prismacolor:
Celadon Green • Bronze • Slate Gray
• Henna • Black • Light Umber • Burnt
Ochre • Tuscan Red • Terra Cotta • White
• Blue Slate • Copenhagen Blue

OTHER
HB pencil for sketching.

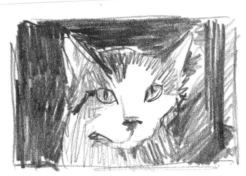

Plan Your Composition

Plan your format and composition carefully. I have painted and drawn this gorgeous animal every way but close up, so I decided to zero in on that sweet face. The thumbnail on the left is too mundane and static; it's boring. An extreme closeup is riveting, and can't help but involve us.

Use your thumbnail sketches as value sketches as well. The dark fur surrounding the features helps to focus attention—as if that's necessary with those eyes gazing back at you!

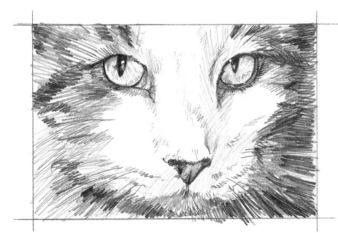

1 A larger graphite sketch, to scale, will help you decide on details, placement and expression. Don't get *too* carried away; a simple zigzag stroke to fill in the values is sufficient. This doesn't have to be a finished graphite drawing.

2 When you have your plan firmly in place, transfer your sketch to your paper's surface. Lay tracing paper over the drawing you made and trace only the most basic of guidelines (you don't want a lot of graphite showing through the colored pencil). Turn the tracing paper over and scribble with the graphite pencil just along the lines that you want to transfer. Lay this right side up over your bristol paper and draw over the lines again, lightly. Lift a corner to make sure you're getting a transfer. (You may want to tape the tracing paper to your final surface so it doesn't shift around as you transfer.)

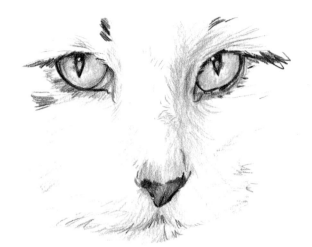

3 If you start with the eyes and nose, everything else will fall into place more easily. That's where you want the most detail. Next, lay in the basic tones, letting your pencil move in the direction of the hair growth. Create shadows with a combination of blues and grays, and begin to suggest the cat's markings.

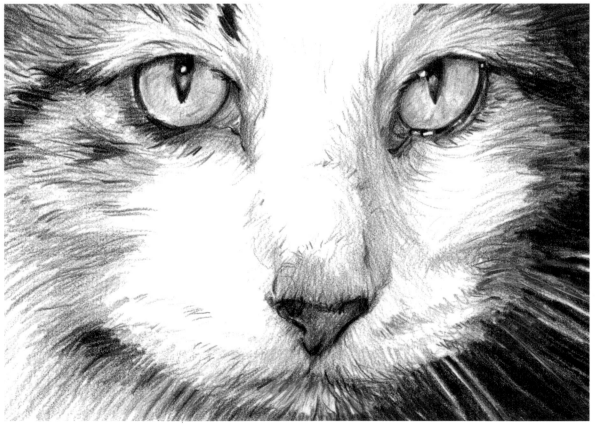

4 Now add the darks in the fur, following the direction of the stripes and the hair growth. Add shadows, highlights and details until you are satisfied with the effect. If you can, scratch through the deepest shadows to suggest whiskers and individual hairs.

FUZZ
Colored Pencil
4" × 6" (10cm × 15cm)

Watercolor Step by Step

Watercolor is a marvelous, beautiful, transparent medium. Watercolor is more versatile than many people suppose, much more controllable than we fear and not nearly as frightening or frustrating. You don't have to do it perfectly the first time because you can adjust mistakes. You just need to learn a few tricks for handling the medium. All it requires is practice and patience.

The main problem many people encounter with watercolor is a tendency to let colors all run together, so they end up with a muddy mess. To avoid this, you just need to allow an area to dry before painting next to or over it. There is an oft-stated dictum about watercolor: Work from large to small, and from light to dark. That's certainly the easiest way to control it. Using your largest brushes, paint the largest areas in the lightest colors. If they touch or overlap, let them dry in between.

You can work progressively smaller and tighter as you add your darkest darks, but try to use the biggest brush you can for as long as you can, to keep from getting tight and stiff. The painting will benefit, as will you because you're not nearly as likely to get bored.

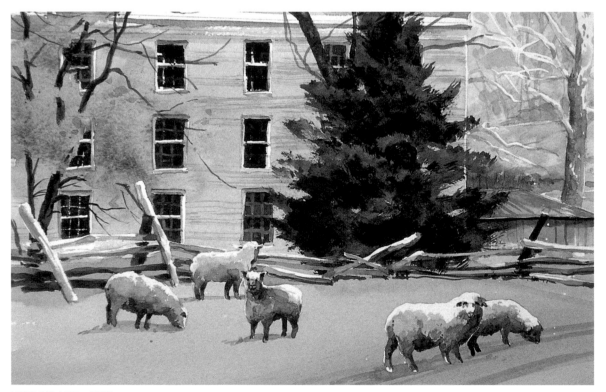

WATKINS MILL, APRIL
Watercolor
11" × 15" (28cm × 38cm)

Watercolor Materials

What you use for watercolor depends a great deal on whether you like to work large or small, loose or tight, indoors or out, so this list will necessarily be fairly general. The basics are the basics!

Recommended Equipment for Watercolor:

- **Watercolor paper.** Try a sample pack so you can experiment with rough, cold-pressed and hot-pressed paper. This should be at least 140-lb. (298gsm) so you don't have to stretch it to keep it from buckling.
- **Watercolor paints.** Use a good brand, either pan or tube paints, but avoid student-grade paints. They're simply not worth it. Winsor Newton, Daniel Smith, Grumbacher (professional grade) and Schmincke are among the best brands.
- **A large plastic or enamel palette.** This is good for indoor use. A portable watercolor set works just fine for outdoors.

- **Round watercolor brushes.** I recommend brushes with red sable or synthetic hairs in sizes no. 3, no. 5, no. 8 and no. 12.
- **Flat watercolor brushes.** I again recommend sable or synthetic hairs. Choose a variety of sizes, but it's best to start with ½-inch (13mm), ¾-inch (19mm) and 1-inch (25mm).
- **A fan brush.** Select a medium-sized brush with in bristle or synthetic hairs.
- **An old toothbrush.** This works for spattering paint.
- **Water container.** This can be a mason jar, Loew-Cornell Brush Tub or an old army canteen with a cup.
- **Rags or paper towels** for wiping up spills, blotting washes and even painting. I hold one in my left hand while I work so I can wipe my brush or the painting quickly.
- **Natural sponge** for texturizing the paint.

QUICK TIP

PAPER WEIGHT This is not what you hold your paper down with, but the weight of the paper itself. Paper is weighed by the ream, not the sheet, so a sheet of 80-lb. (170gsm) paper is actually quite thin for watercolor. Unless it is stretched, it will buckle. Most people find stretching a very tedious and sometimes tricky process, so I'm just going to skip the directions and recommend you start with 140-lb. (300gsm) paper! This may buckle some, but if it's taped, stapled or otherwise fastened to your painting board or table, the waves should flatten out as the paper dries. The heaviest paper—300 lb. (640gsm) paper—is almost like cardboard. It seldom buckles even under the wettest of techniques, but it's considerably more expensive.

Rough Paper

Cold Press

Hot Press

Watercolor Brushes

There are many kinds of watercolor brushes, but the basic types are rounds and flats. My smallest round brush is a no. 1 (though they're made even more tiny) and my largest is a no. 12 or 14 (though they come larger). Flat brushes are measured differently; the smallest I use is a ¼-inch (6mm) and the largest I use is a 2-inch (51mm). I find a no. 5 and a no. 8 round and a ½-inch (13mm) and 1-inch (25mm) flat meet my basic needs, though occasionally a *spotter brush* is good for those places where you really don't want an unexpected "splot" of too-wet color (the sparkle in an animal's eye, for instance). Splotters look like round brushes, but tiny.

A *fan brush*, with the hairs literally spread in a fanlike shape, can be useful for blending or painting fine, repeated lines in fur, hair or grass. Some artists "barber" their fan brushes with finger-nail scissors to resemble a pixie haircut, which provides an irregular effect.

Riggers or *liner brushes* have longer-than-normal hairs in relation to their size, and can be useful for painting long, unbroken and relatively uniform lines for vines, branches or hairs.

Take care of your brushes by washing them out at the end of your painting session and wiping them on a tissue to reshape to their original configuration. Don't leave them standing in water overnight, or you stand the chance of loosening the glue in the metal ferrule or the hairs becoming twisted or mis-shapen. If the latter happens, you can rub the hairs over a bar of soap and allow them to dry in the correct position to re-set.

A stiff brush intended for use with oils or acrylics, a round stencil brush or even an old toothbrush can make a good spattering tool (see page 57).

QUICK TIP

RECYCLE BRUSHES Don't throw away brushes that look absolutely useless! They can be wonderful texturing tools. I had an infestation of moths in a drawer of old brushes. Instead of throwing out the damaged, chewed-up brushes, I tried them as texture brushes. Now they're among my favorite tools.

A Variety of Brushes

The round brush (far left) is capable of all kinds of strokes and squiggles and dots. Artists made do for centuries with rounds, and as versatile as they are, and as many sizes as they are made in, it's no wonder!

The next brush (second from left) is a flat, which once was used just for lettering or calligraphy. Artists now have found how truly versatile and useful they are! Like rounds, they come in a great variety of widths.

Riggers or liners are capable of nice, long, relatively uniform lines. You'll find all kinds of uses for these.

Fan brushes (right) are often given a haircut by their watercolorist owners to make more interesting, less uniform marks. Synthetic hairs make finer lines; bristle brushes are more emphatic.

Three "Rescued" Brushes

Experiment with what your damaged-beyond-repair brushes will do before discarding them. Make lines and squiggles and dots. Press the tips straight down on the paper, move them all around. You'll probably find that you can add them to your collection of useful tools.

The third brush (far right) is a flat that was used in acrylic paint and not thoroughly cleaned before the paint dried in the hairs near to the ferrule. It wants to take on an open oval shape and the hairs tend to separate when wet. This too makes some great textural effects.

Getting to Know Watercolor

To warm up or to familiarize yourself with the medium, try these traditional watercolor washes: *flat, graded* and *variegated*. Then branch out into *wet-in-wet* and *glazing*, and you'll be well on your way to being a watercolor virtuoso.

WORDS TO KNOW

BACK RUNS When water or wet paint leaks back into an area of the painting, it causes an uneven and unintended splotch. Sometimes these are happy accidents, but mostly they aren't.

Flat Wash

To make a flat wash, use a large flat or round brush and mix up a good-sized pool of water and pigment. Draw your brush across the top of your wash's area to make a horizontal line. Keep your paper slightly tilted to encourage a bead of paint to form at the bottom of the stroke. Refill your brush and make a new stroke, slightly overlapping the first and picking up that bead of pigment. Continue on down the page as far as you wish. Pick up the remaining bead of pigment with a clean brush. If the brush isn't clean or is too wet, paint will bloom back into your smooth wash.

This is one of the most difficult washes to pull off perfectly. It's easier, oddly enough, on rougher watercolor paper since the pigment "averages out" as it settles into all those little valleys.

Graded Wash

A graded wash is essentially the same thing as a flat one, but it's achieved by adding successively more water instead of reloading your brush from the pigment puddle. Don't forget to pick up the bead of wet paint on the bottom edge, even on the final pass, to prevent back runs.

Variegated Wash

I find the variegated wash most useful. To create it, roughly apply paint, varying both the color and your strokes as you go. You'll find a million places to use this one, and will develop your own favorite way of applying it. Here, I roughly mixed blue, yellow and red on the paper, allowing them to blend.

Wet-in-Wet

Painting wet-in-wet will give you soft transitions and sometimes unexpected effects very useful for shadows, suggesting volume or just adding interest. Lay down an area of color and immediately splash another color right into or next to it, allowing the two to touch and blend.

Glazing

Glazing is just the opposite of wet-in-wet. Let your first wash dry thoroughly, then paint another layer over it. You can add an almost infinite number of glazes or only one. Try not to lift or muddy the wash underneath. With glazing, you can create a third color, make a color more subtle, add a misty opaque or create a sunset glow.

Watercolor Special Effects

Here are a variety of interesting special effects you can get with various tools. Some are inexpensive, others are free and some will set you back a bit, but all are worth exploring. Just don't try to use all of them in the same painting!

Masking

Masking fluid, sometimes called liquid mask or liquid frisket, is liquid latex. Paint it onto your paper where you want to preserve whites, but don't use your best watercolor brush because it dries quickly and could spoil your brush. You may wish to wet the brush with soapy water first to help prevent the liquid latex from drying in it, but in any case be sure to wash it out quickly.

I usually choose an inexpensive, synthetic brush from the craft section of my local discount store for this process. You can buy an entire set for much less than you pay for good artist's brushes, so if you ruin one after a few uses, you can just toss it.

You can also apply masking fluid with a bamboo pen, a sharpened stick, a palette knife, a stencil brush or one of the special tools designed just for that purpose.

Masking Fluid

Allow masking fluid to dry thoroughly before painting over it. Let your wash dry, then remove the mask carefully, pulling away as much as you can. Rubbing too vigorously with a fingertip can damage your paper. You can buy a square of India rubber we used to call a "rubber-cement pickup" for this purpose; most art supply stores will know what you mean if you say that. Today, however, it's often called a "Maskoid remover." The white areas left behind when the mask is lifted can look too stark or pasted on, so paint over them or soften an edge with a brush and clear water. Lift excess pigment with a tissue.

Drafting vs. Masking Tape

You will find that drafting tape is marvelous for taping your paper to a board. It will hold securely and give you a beautiful, clean edge when pulled off, as shown at left. It's much less likely than masking tape to damage the paper. You can also mask small areas to protect the white paper when you paint over it; cut or tear the tape to the shape you want. Rub it down with the back of your fingernail to prevent paint from creeping under the edge. Just be sure to allow the paper to dry completely before removing the tape.

If you want, fill in the protected white area, glaze over it or soften the edge with clear water, as was done with the shape at center.

You may find it easiest to cut more precise shapes, such as the birds at the top, by putting a piece of tape down on a smooth surface, cutting out your shape with a craft knife and then lifting it carefully to reposition on your paper. The piece of tape it is cut from can also be used as a mask, as was done with the two bird shapes at the top.

Paper Towel Blots

Tissues or paper towels are excellent for wiping brushes, cleaning your palette or lifting too-wet areas. They can also be great texturing or lifting tools.

On the right side of this example, a wet wash has been lifted with a dry towel. A damp towel produces a softer effect, as on the blue on the left side; it looks rather cloudlike. The lacy green shapes at the bottom were stamped on using the towels.

Sponge Work

Sponges can be used to lift pigment, soften an area or even to apply paint. The effect can be quite interesting. Try both natural and synthetic sponges to see which suits your needs.

You can lift an area either while it's still wet, or wait until it dries and use a sponge wrung out in clean water. Blot the loosened pigment often with a clean paper towel to remove it. (Some pigments lift more easily than others.)

Table Salt and Water Spatters

Some artists sprinkle salt into a wash to create texture and sparkle. Do this when the wet wash has just begun to lose its shine to achieve the best effect (center). If you do this too soon, the salt won't have much effect (left). If you wait until the paint is too dry, it won't have any effect at all (right). Allow the painting to dry thoroughly and then brush away the excess salt.

You can get a similar effect by spattering plain water with some pigments when the wash is at the right stage of dampness as in the bottom square below. Experiment to see what gives you the effect you want.

Drybrush

By using a dry brush and relatively dry paint, you can create some interesting effects. This technique is extremely useful in creating fur.

WORDS TO KNOW

SPATTERING Spraying paint drops over the painting. Toothbrushes work well for spattering paint. Dip an old toothbrush in paint, direct the brush head toward the paper and then run your thumb over the bristles. (You may wish to cover or mask areas you'd like to keep as they are.)

Knife Scratches

Craft knives can be useful for scraping out highlights such as the light in an animal's eye, a cat's whiskers, highlights in fur, the mullions in a many-paned window, even light-struck weeds or grasses. The broader broken lines at left were done with a scratchboard tool.

Watercolor Painting

For this example, I painted a picturesque nineteenth-century woolen mill in northwestern Missouri called Watkins Mill. The mill has been open to the public for some years, and boasts an up-to-the-minute visitors' center, a brick schoolhouse and church, a lake and nearby camping. You can use a variety of techniques and resource photos to get the effect you're after.

MATERIALS

PAPER
11" × 14" (28cm × 36cm) Watercolor paper

BRUSHES
Nos. 5 and 8 rounds • ½-inch (13mm), ¾-inch (19mm) and 1-inch (25mm) flats • Fan brush with bristle hairs • Synthetic brush for masking fluid

COLORS
Alizarin Crimson • Brown Madder Alizarin • Burnt Sienna • Burnt Umber • Cadmium Yellow Medium • Cobalt Blue • Phthalo Blue • Raw Sienna • Sap Green • Ultramarine Blue

OTHER
HB pencil • Craft knife or single-edge razor • Masking fluid • Paper towels

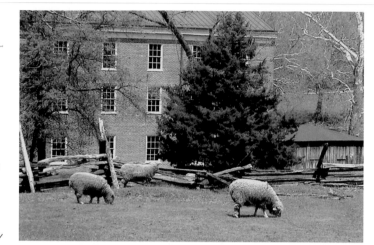

Resource Photos
Pick and choose from your photos to find what you want to include in the final painting. Here, sheep from three different reference photos seemed most interesting. A quick sketch lets you see how they'll work.

Make a quick sketch of
the sheep you plan to
include and the posi-
tions you want them
in. Remember, those
closest to you will look
largest and most
detailed. Make notes
on the sketch, if you
like, or do a detail
sketch in the border.

Transfer or draw your composition
on your watercolor paper with an
HB pencil. Protect areas you want to keep
white, for now, with masking fluid. Here,
the mask covers the window, the sycamore
tree, the light-struck fence and the sheep.

2 Lay in the first washes. Paint around large shapes, but go right over those protected with masking fluid. The background woods are a more obviously variegated wash, using Cadmium Yellow Medium, Raw Sienna and a variety of blues. The grass in the foreground is also variegated. Use Cadmium Yellow Medium with Phthalo Blue to get a stronger, fresher green. Remember to let shadow areas describe the shape of the ground.

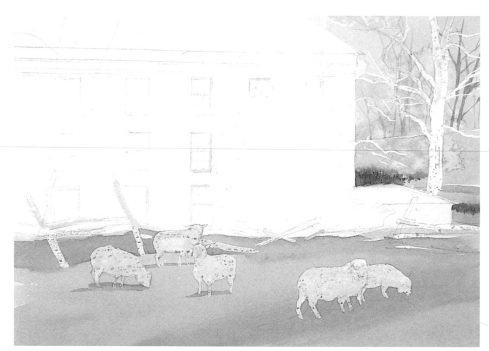

3 Put the first washes on the mill building itself with a mixture of Burnt Sienna, Brown Madder Alizarin and Ultramarine Blue. Quickly wash in the light green of the tree on the left, working wet-in-wet with Cadmium Yellow Medium and a bit of Phthalo Blue. Allow that to dry, then add the shadows under the eaves with Cobalt Blue.

When that is dry, do the first washes of the dark cedar tree with a bristle brush, barbered fan brush or a rescued brush like those shown on page 54. Use a rich mixture of Phthalo Blue, Sap Green and a touch of Alizarin Crimson.

Paint in the dark windows with Ultramarine Blue and Burnt Umber—painting right over the mask—and allow these washes to dry thoroughly.

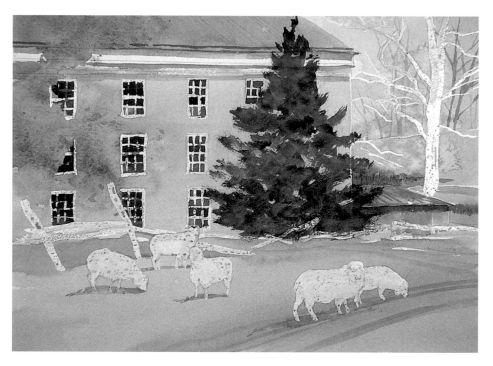

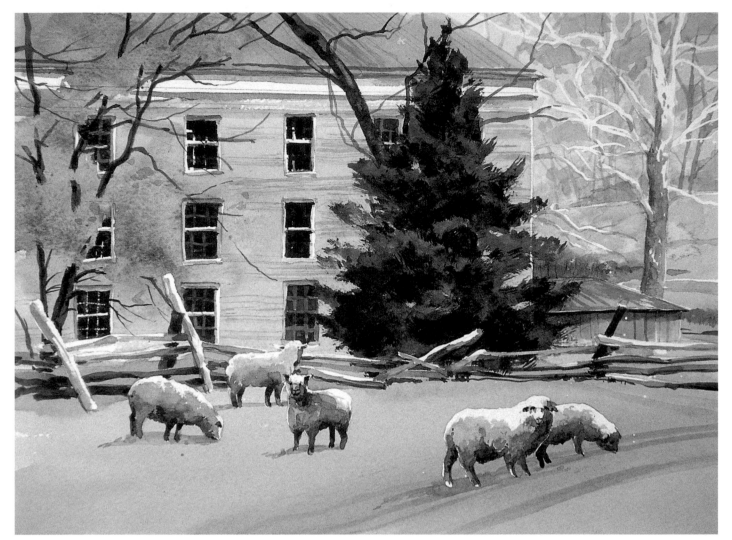

4 Carefully remove the mask from the tree, fence, windows and sheep. Once the mask is removed, paint over the overly wide, too-coarse mullions with another rich layer of Ultramarine Blue and Burnt Umber, just covering the mullions but leaving the window frames. Allow that to dry completely, then scratch in the lines again with your craft knife. Add shadows with Cobalt Blue.

Paint in small variegated washes on the tree trunk on the right and model the shape of the tree. Add the other trees and limbs on that side, and paint the dark limbs on the tree at left that is just getting its young spring leaves. Mix a bit of the same yellowish green with less water so it's darker. Cover the rest of the painting with scrap paper, then use the stencil brush to spatter in a suggestion of tiny young leaves. Continue to model the cedar tree, adding darker shadows and the rest of the limbs, along with a suggestion of the trunk.

Use Ultramarine Blue and Burnt Sienna for the split-rail fence. Paint the shadows on the sheep with a lighter, warmer mix of those two colors, with a bit of Raw Sienna. Leave the upper edges of the sheep white paper, and shade to darker washes underneath, being careful to model their shapes as you go. Remember that the closer animals will be a bit more detailed.

Finish up other details as needed, working over the whole composition until you are satisfied. Suggest a few blades of grass with tiny strokes.

WATKINS MILL, APRIL
Watercolor
11" × 15" (28cm × 38cm)

Watercolor Pencil Step by Step

Watercolor pencils, sometimes called water-soluble pencils, are pencils with "lead" made of pure compressed pigment that dissolves in water. These pencils are of various quality. The better ones are densely pigmented and dissolve readily when touched with water, while others are dry and scratchy. As with any other medium, you get what you pay for.

This medium is extremely versatile, but there's a bit of a misconception about what you can and can't do with these tools. You really can't create a completed, full-color drawing and then just wet the whole surface; you'll get a muddy mess!

You still need to plan (unless your initial drawing is *very* simple) and work in stages for greatest control.

Watercolor pencils are great portable sketching tools, but you can also create marvelous finished works with them. If you've bought a good brand, they should be as permanent as watercolor paint.

Watercolor pencils handle differently from either watercolor paints or colored pencils, but they can combine good qualities of each. (For those who are interested in a complete course, check out my North Light book, *Watercolor Pencil Magic.*)

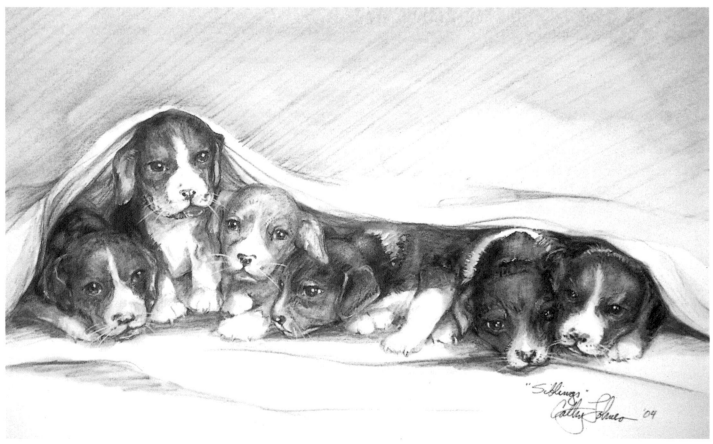

SIBLINGS
Watercolor Pencil
7" × 11" (18cm × 28cm)

Watercolor Pencil Materials

There are many brands of watercolor pencils available today, each with own characteristics. You'll recognize many famous old names among them. Some watercolor pencils are hard; some are softer and more buttery. Some have very intense, rich pigmentation; others have less and may be more suitable to sketching than painting. You'll soon discover which best suits your needs—and your style—as you experiment with them.

Watercolor pencils are usually encased in wood, but some brands are "all lead," meaning that the entire pencil is pigment, covered with a varnish or paint film to keep your fingers—and your art—clean. These are very nice for broad effects because you can use the side of the pencil, from the tip to the farthest end of the sharpened area, as shown in the illustration at right. This allows you to cover a large area more quickly.

You can also buy blocks or crayons of pigment in stick form. Some brands, such as Lyra Aquacolor's water-soluble wax crayons, are much softer and more easily blended than others, so you may want to try a small set of each type before spending a lot on a large set of colors. Like the whole end of a woodless pencil, these blocks are excellent for covering broad areas. The larger, softer crayons are not as good for detail work, however, so you will probably prefer to have a combination.

Recommended Equipment for Watercolor Pencils

- **Watercolor Pencils.** There are sets of watercolor pencils available with any where from ten to 120 pencils.
- **Watercolor paper.** Use paper that weighs at least 140-lb. (300gsm) to prevent buckling. It's best to work with cold- or hot-pressed paper because it can be difficult to draw on rough paper.
- **Round watercolor brushes, sable or synthetic.** A good selection would have a no. 3, no. 5, no. 8 and no. 12.
- **Flat watercolor brushes, sable or synthetic.** I rely on a ½-inch (13mm) and a 1-inch (25mm) brush when working with watercolor pencils.
- **Water container.** A mason jar, margarine tub, commercial container or even an old canteen will work for this.
- **Paper towels or rags.**
- **Natural sponge.**
- **Pencil sharpener.** If you work at home, an electric pencil sharpener helps avoid breaking the lead. A good-quality hand-held sharpener for field work will do, or a sharp craft knife.
- **Pencil carrier.** The original packaging often works just fine, but you might prefer to keep them in a jar or mug at your desk.

All-Lead Pencil
You can get much broader effects when you have a lot of ground to cover by using an "all lead" pencil (shown at left). A traditional wood-encased pencil will take longer to cover the same area.

Paper Makes a Difference
The bar of dark turquoise at the top is on a hot-pressed paper, Aquarius II from Strathmore. The wash looks smoother in part because the paper itself is smoother and allows a more even application. Below, rough Gemini watercolor paper from Strathmore shows the interesting textured effect possible on a coarser paper.

Getting to Know Watercolor Pencils

As with any medium, it's best to explore a bit before hoping to dive right in to make a completed picture. Watercolor pencils in particular seem full of surprises because we expect the transition from pencil (drawing) to watercolor (painting) to be possible in one leap. In most cases it isn't, and requires a bit more patience and planning than we might think.

These exercises will prepare you to discover the versatility of this medium, and enjoy the trip!

uneven coat

more even coat

watercolor wash

Even and Uneven Washes

How you apply your watercolor pencil makes a bit difference in the final effect. An uneven coat (top) results in an uneven wash, without some pretty aggressive blending. A more evenly applied pencil (middle) results in a much more even wash, though still with a bit of texture typical of water-color pencils.

For comparison, note the square of orange watercolor paint (bottom). Pigment is pre-mixed on your palette and then applied to the paper your wash is much smoother. Note that the color is not as intense as the two watercolor pencil samples. This is in part because they're pure pigment direct from the pencil. The orange was mixed from yellow and red tube colors.

Lyra Aquacolor water-soluble wax crayons

Rexel Derwent watercolor pencils

Faber-Castell Albrecht Durer watercolor pencils

Different Brushes

Blend a little or a lot with clean water. You may wish to use a brush with slightly stronger hairs than squirrel or even sable for lifting and blending. At left, the blue and red lines are still very visible. These were wet with a sable brush. In the middle, a synthetic nylon brush blended a bit more aggressively, and at the right a bristle brush lifted the pigment and blended it smoothly.

Color Samples

Try out your pencils. Make a sampler sheet of all the colors you have—or at the very least, a sampler of the colors you think you'll be using for a specific project! Some of these change rather drastically when wet, and it's best to be prepared. Keep part of your sample dry, for comparison, and mark them with the name or number if you plan to keep this for future reference. Wash out your brush with clear water each time so your color remains true.

A Flat Wash

Try making a flat wash with your pencils. Unlike with watercolor, part of the trick here is how you put down the initial layer of colored pencil. For a flat wash, make as smooth an application as you can, then wet with clean water and a brush, stirring slightly to lift and blend the color. The darker bar in the center of the green sample is with the brush run only once through the pencil, and the lighter, smoother area to the right is the result of more aggressive blending. Lift the excess water and pigment when you reach the bottom.

A Graded Wash

For a graded wash, apply watercolor pencil densely where you want the richest color, then lift as you go down the paper, using a lighter and lighter touch till it fades away. Blending to make a graded wash is fairly easy, just be sure to work from top to bottom and refresh your clean water if necessary. Lift the excess water and pigment when you reach the bottom.

Timing is Everything

Try making a squiggle of pigment, then wetting it. Here, it is blended richly and well.

Follow up by wetting an area with clean water and drawing into it. Notice how the lines tend to remain emphatic? They won't lift easily.

There's a time and a place for both techniques. Neither is superior because both are useful.

blue, orange and
red-brown shades of brown

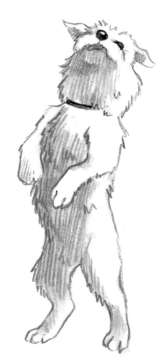

Adventurous Color Combinations

Even if the animal you are drawing is shades of brown, don't feel you're limited to those colors. Try mixing color right on your paper for more exciting combinations. Here, blue, orange, and red-brown are a livelier combination than the shades of brown at right, beside them.

Hairlike Marks

Watercolor pencil works very well to suggest hair or fur. Just make the lines as bold or delicate as you want, following the direction of hair growth. Lift a bit on the ends to suggest hair's tendency to become more pointed at the end. Use several colors for a natural effect, then blend lightly with clear water. Let some of the lines remain to give the effect of individual hairs.

Using Blue for White

I drew this little guy quickly using watercolor pencils. The loose lines in a variety of blue work to suggest the shadows of his shaggy white hair. Light grays also work well in suggesting white fur.

Watercolor Pencil Painting

Choose a subject you have a strong feeling for. For this demo, I chose the beagle puppies I grew up with. My father raised beagles and my older sister's father-in-law was a professional photographer, so I had some wonderful resources to work from.

I combined several photo resources to get this composition. Sketch on tracing paper so you can move things around until you have the composition you want. When combining photos, it's important to make sure that the position, perspective and light source "agree" and that what you're doing makes sense. Remember, follow through when working with a subject like this: Where would the rest of the pups' bodies be? Where are their feet? How would the littermates overlap? Ask yourself questions like these to avoid most common mistakes.

MATERIALS

PAPER
Sturdy watercolor paper
(cold- or hot-pressed)
Paper towels

BRUSHES
No. 5 round • ¾-inch (19mm) flat • Small bristle brush (round or flat)

COLORS
A variety of browns from Burnt Umber to Coral • Black • Indigo • Pink • True Blue • Raw Sienna • White

Make Color Samples
The colors of the pencils themselves can be deceiving. If you want to feel more secure about your color choices, make a sampler with the pencils you plan to use. Wet each one with clear water so you know what to expect. I discarded the too-orange pencil on the top row because it was inappropriate for this subject.

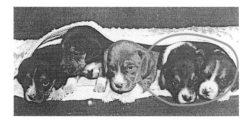

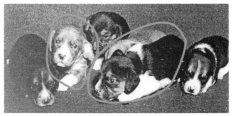

Reference Photos
Combine as many resources as you want to create your composition. Check to see how the elements work together and rearrange them if necessary.

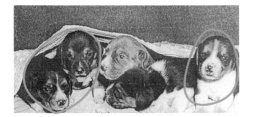

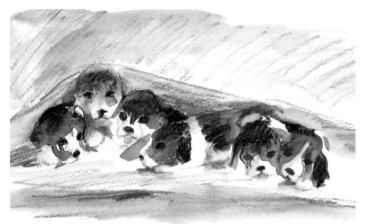

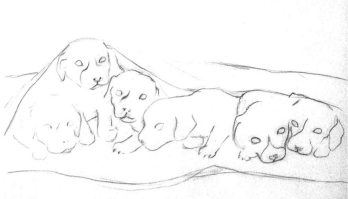

1 Make a small working sketch, if you like. No need to feel tied to this, it's just a way of noodling: exploring color, composition and placement.

2 Here, the finished tracing-paper overlay has been transferred to the watercolor paper. I replaced the "high" pup with one in a more interesting pose. If the direction doesn't suit your composition, flip the tracing paper to orient your subject the other way.

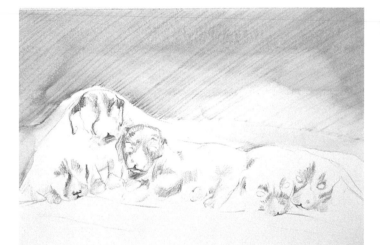

QUICK TIP

GRAPHITE PAPER You can use graphite paper (Saral is a common brand) to transfer your drawing to your working surface, if you like. Tape your sketch to the watercolor paper so it won't move around, and slip a sheet of graphite paper between your sketch and your painting surface. Trace as usual. Lift a corner to make sure you've transferred all you need. You can reuse the graphite paper as long as it leaves a mark; it's very practical stuff.

3 You want a subtle background that doesn't detract from your subject, so lay in a grayed version of the primaries. Lay in lines to make nice, neutral tones: a blue-gray for the blue, reddish brown for the red and Raw Sienna to stand in for yellow. To blend the lines, use a no. 5 round to wet these with clear water. It it isn't necessary to make the lines disappear entirely; the slight linear effect adds interest. You may want to hold your paper upside down and pull the wash away from the subject area so you don't get too much incursion or dripping. Allow the paper to dry, and add a second layer if you wish.

Feel free to adjust the composition as you go; the silver beagle pup is now the one next to the tallest one, and the blanket covers more area so as not to detract from the puppies.

4 Lay in the lightest tones in the pups, using blues and blue-grays for shadows, and the lighter tones of brown. You can see here that some have been blended with clear water and some have not.

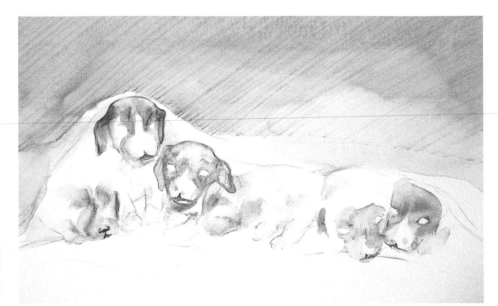

QUICK TiP

DON'T FORGET TO RINSE
Rinse your brush often when blending watercolor pencils to keep colors fresh and true.

5 Begin to add the darker shades, and blend a relatively small area at a time to avoid muddiness or smearing. Drag your wet brush from one area to another to soften the edges; it creates a much more natural and subtle effect. Don't worry if the pups seem to blend together like Siamese twins; they do in the resource photos, too, so this will look natural in the finished painting. Note how the small areas look before they are moistened. The lines will blend once wet.

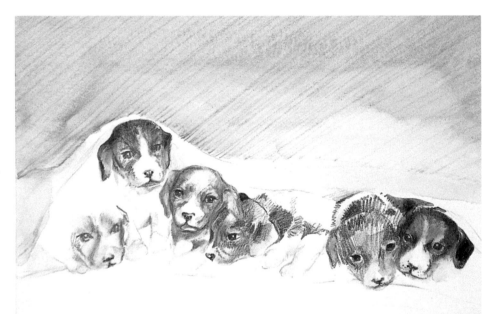

QUICK TiP

LOST-AND-FOUND EDGES
By creating blurry, soft edges in less important areas, and sharper, harder edges around the center of interest, you can focus your viewer's attention where you want it.

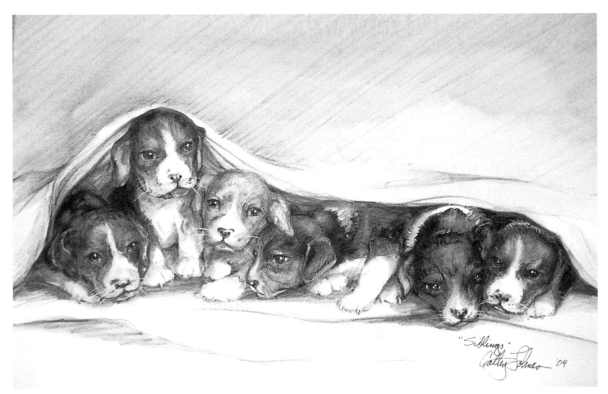

6 Finish up all the fine details. You can concentrate more detail, more contrast and more interest where you want the viewer's eye to go, but don't neglect the other areas. Lift areas you want lighter or less busy with a small bristle brush and clear water, blotting often to remove loosened pigment.

QUICK TiP

MAKING ACCENTS For dark, or light-colored accents, remember that you can draw with these pencils as well. The whiskers and claws on these pups were done with a sharpened white pencil after everything was dry.

For a more emphatic white, as in the eyes, moisten the tip of the white pencil and touch it firmly to your paper.

Getting Sharp Detail
If you want a small, sharp detail and can't get it using the pencil in the traditional manner and then blending it with water, remember that these pencils are solid pigment. Either touch your wet brush directly to the side of the pencil's "lead," just as if it were a cake of watercolor (which it is), or make a squiggle of color on a piece of scrap paper and pick up the pigment with your moistened brush. Paint as you would with watercolor.

Acrylic Step by Step

Acrylics are wonderful to use for on-the-spot work as well as in your studio. They dry fairly quickly, clean up with soap and water, and offer a unique set of benefits to painting animals—not the least of which is their marvelous versatility. You can use them thinned with water for a transparent watercolor effect or for glazes, or as they come from the tube for a more opaque, oil-like appearance. You can also thin them with matte or gloss medium for a juicier effect. You can paint light to dark or dark to light and they can be as impressionistic or as detail-oriented as you like.

However, some of these wonderful characteristics can create problems if not handled correctly. Acrylics dry quickly on your working surface, on your palette and in your brush, so you need to cover your palette when not in use—

even if you just go off to get a cup of coffee or answer the phone. It also helps to spray it with clear water occasionally. Some palettes made especially for acrylics have lids and stay-moist inserts. There are also drying extenders you can try. Be sure to clean your brushes promptly; if the paint dries in the metal ferrule, it's virtually impossible to get out.

On the plus side, you can paint lights right on top of your darks without lifting or muddying them, as long as you've allowed them to dry thoroughly. This is great for suggesting fur, whiskers or the sparkle in an animal's eye.

No question about it—acrylics are a challenge, but their versatility and vibrancy more than make up for any shortcomings, real or imagined.

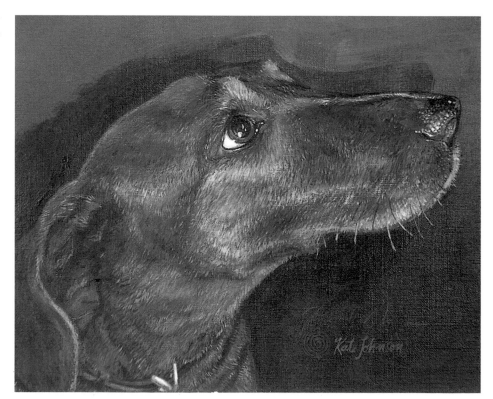

THE LOOK OF LOVE—SARAH
Acrylic on canvas paper
9" × 12" (23cm × 30cm)
Collection of Joseph Ruckman

Acrylic Materials

Consider a set of smaller tubes of acrylics to see how you like them, if you've never used this medium before. Liquitex, Daniel Smith, Golden and others make tube colors as well as a more liquid form in jars. If you want to use the impasto technique, you'll want the tube paint. Thinner applications and watercolor effects are somewhat easier to achieve with jar colors.

If you opt not to buy a preselected set, purchase a tube or jar of the primaries—red, yellow and blue—plus white, black and a few earth colors. Many artists prefer having both a warm and a cool of each primary for the widest range of mixing possibilities.

Recommended Equipment for Acrylics

- **Acrylic paints, tube or jar.** Jar paints are more liquid and require less mixing with water or medium, but the tube paints will let you use a bold impasto technique. Liquitex, Golden, Daniel Smith and others are good brands. Avoid craft paints, though, since they are less pigment-dense.
- **Matte or gloss medium.** These are for mixing and thinning your paints. You can also use water, if you wish. You can use the matte or gloss medium as a varnish at the end.
- **Gel medium.** Adding this to your regular paints thickens the paint for an impasto effect. You can also buy a variety of textured acrylic additives. These can be fun, but they're not necessary; all you need right now is paint.
- **Round synthetic brushes.** Try no. 3, no. 5, no. 8 and no. 12. Acrylic is more difficult to clean from brushes than watercolor, so stick with the less expensive synthetic brushes.

- **Flat synthetic brushes.** Try the ½-inch (13mm) and 1-inch (25mm).
- **Painting surface.** You have a variety of choices for your painting's surface. Acrylic works on stretched canvas, canvas board, canvas-textured paper and even heavy watercolor paper. You can also use acrylics on stone, wood or Masonite. Acrylics are versatile as well as tough and flexible.
- **Water container.** You may also need containers for other mediums, if you use them.
- **Palette.** Dried acrylics will come off a china or enamel palette with relative ease. There are also special palettes that keep your paints moist, but a palette with a cover will keep the paint moist longer, too.

- **A spray bottle of water.** Spritzing your palette (or your painting) with water will keep paint from drying.
- **The usual paper towels or rags** for quick pickups, cleaning your palette or adjusting the painting.

WORDS TO KNOW

IMPASTO In this technique, paint is applied so thickly that brushstrokes are clearly visible. The raised paint adds exciting texture to the painting.

Mixing Colors

A warm and a cool version of each primary color will make it easier to mix clean secondary colors—orange, violet and green—not to mention the tertiary colors and all the mixtures between. You can gray a primary color with its complement (the hue directly across the color wheel) or mix them with each other to produce a nice range of gray-to-brown neutrals, as shown in the center.

Getting to Know Acrylics

If you haven't used acrylics before, take a
little time to become familiar with the
medium. Do some traditional exercises,
experiment, play around, have fun!

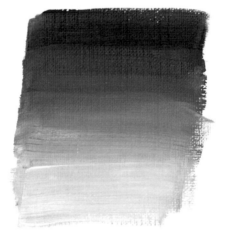

Green and Brown Squares

It's fairly easy to make a flat area with an opaque
medium like acrylics. Be aware, however, that even
some "opaque" pigments are more translucent
than others. You may want to test the opacity of
your paints by making a black line with colored
pencil or ink, then painting over it to check trans-
parency. Here, the Olive Green is considerably
more "see-through" than the Burnt Sienna.

Grades of Value

Sometimes you will need to grade from one value
to the next. Since acrylics can be used both for
transparent effects (such as watercolors) and for
more opaque applications, try them both ways.
On the left is the graded wash of Burnt Sienna,
with more and more water added to dilute its
strength. On the right side, the value transition was
made by adding white.

QUICK TIP

TRANSPARENT COLOR If you
mix acrylic paint with plenty of
water, you can thin the paint to a
watercolor-wash consistency. Some
of the paints will require aggressive
mixing, but the glazes can definitely
be worth it.

Test Your Paint and Brushes

As you did with the other mediums, try out acrylics with the brushes in your arsenal. On the left, a ¾-inch (19mm) flat brush was put through its paces with an opaque red. On the right, the same basic exercises with a round brush.

Scumble With a Flat Brush

A very rough, free, scumbling stroke can be quite useful when painting with acrylics. A flat brush was used here, mostly on its side, to create this very loose, textured area. This would be useful for foliage, earth and, with a bit more control, the body of an animal.

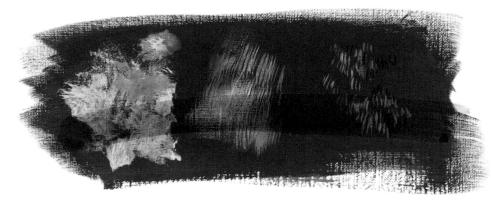

Different Techniques for Suggesting Hair

At the base of all three of these examples is a dark band of color that was allowed to dry. The example on the far left shows the scumbling technique, the center example was stroked lightly with a fan brush and the example on the right was created with individual strokes of a fine-pointed brush. Finally, a glaze of transparent color was applied over top. In practice, this glaze could be lighter or darker, warmer or cooler, to suggest shadows or reflected lights, or simply to unify colors.

Use a Fan Brush

A fan brush is particularly useful with acrylics, not only for blending but for creating fine, linear strokes that suggest grass, weeds or the fine hairs in an animal's pelt.

Acrylic Painting

Acrylics offer some wonderfully versatile painting opportunities. Acrylic is a thicker medium than watercolor and it has a wider range of opaque and transparent pigments. Also, it isn't necessary to plan every detail or painstakingly draw your sketch onto the canvas; you can adjust as you go along.

Textures, mood, atmosphere—all contribute to the final painting. For this painting, pay attention to suggested details as well as carefully delineated ones.

MATERIALS

SURFACE
Gloss medium (optional)
Canvas-textured paper
Masking tape

BRUSHES
¾-inch (19mm) flat brush • No. 5 round • No. 2 round

PAINTS
Burnt Sienna • Hooker's Green • Ivory Black • Naples Yellow Hue • Payne's Gray • Phthalo Blue • Raw Sienna • Sap Green • Titanium White • Ultramarine Blue

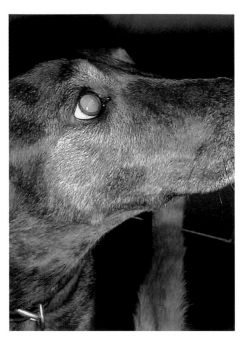

Reference Photo
You can mix and match your subject from a variety of resources—photos, sketches, direct observation—and change things as needed. In this detail, you can see that the beautiful Sarah's eyes caught the light of the flash. I obviously couldn't paint that, so I worked around it. I also had to add her nose, but that wasn't difficult.

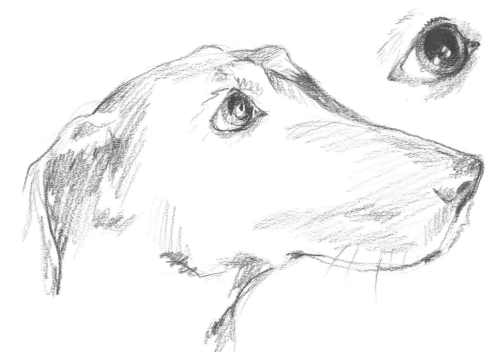

1 Sketch your subject first to make sure of your composition and the accuracy of your observation. Pay attention to the relationship between eyes, cheek and nose. If needed, zero in on a detail you want to explore, such as that no-longer-green eye. (You'll notice I omitted the yellow cat's tail below Sarah's mouth, too!)

2 Tape your canvas-textured paper to a rigid support. When you're sure what you want to do, sketch the subject onto your canvas-textured paper.

Your ¾-inch (19mm) flat will work well for this, but you can use a larger brush for laying in the background if you prefer. You can be loose and free here.

Because the eye is what will capture the viewer's attention in the finished piece, try getting the main details down first. Watch the shape and position of the pupil, given the angle of the head.

QUICK TiP

MIX ON THE CANVAS You can mix colors on your palette, of course, but you can also mix on the painting itself. You'll get fresh, interesting mixes that way. These mixes aren't always perfectly blended, so you'll have touches of unmixed color here and there. Colors mixed on the canvas are often more lively than the carefully mixed homogenous colors.

3 For now, you should just block in areas with color and some initial texture. You can adjust these beginning areas and add a greater degree of detail later.

Mix Burnt Sienna, Raw Sienna and a touch of Ultramarine Blue to paint the first layer of the dog's glossy coat. Add Titanium White to the mix where the highlights will appear later. Don't worry about getting them perfect at this stage—you'll be able to make adjustments as you go.

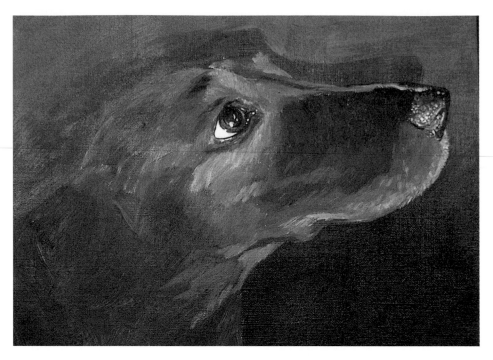

4 Continue working on the shiny coat using varying mixtures of Titanium White, Ultramarine Blue, Burnt Sienna and Payne's Gray. Your smallest brush will allow you to capture the lovely brindled colors of Sarah's coat. Use quick, short strokes with your smallest brush to suggest individual hairs, or use a drybrush technique. Remember to vary the colors, using the lightest ones where the light strikes that shiny coat.

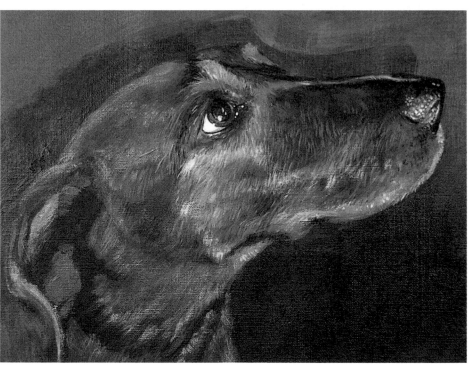

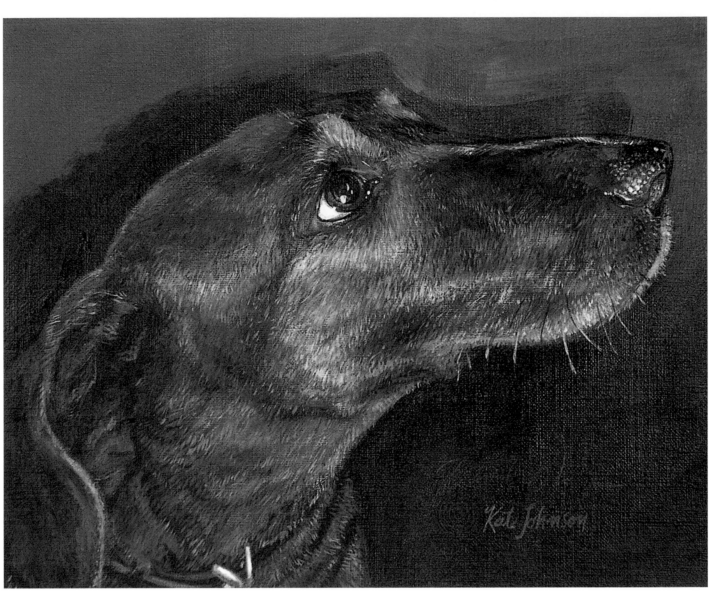

5 Let your work sit for a while; it's always good for a painting to gestate. If one area fights with another, consider ways to modify it, simplify it, push it back or add a bit more detail. When you're sure you're finished, allow the painting to dry thoroughly and carefully remove the tape.

THE LOOK OF LOVE—SARAH
Acrylic on canvas paper
9" × 12" (23cm × 30cm)
Collection of Joseph Ruckman

Details, Details, Details

There are times when a single beautiful detail is what brings a whole work to life; you look at it and say, "*Yes*, that's how it is." I love it when that happens, so I aim in that direction when painting or drawing animals. The degree of detail you include is up to you; it's not necessary to paint like a photorealist if you don't want to. On some occasions, it's more effective to suggest the greater part of your subject in a simple, abstract manner, adding only a few accurately depicted details. (And of course, sometimes just the abstract form itself is enough—but that's not what this chapter is about!)

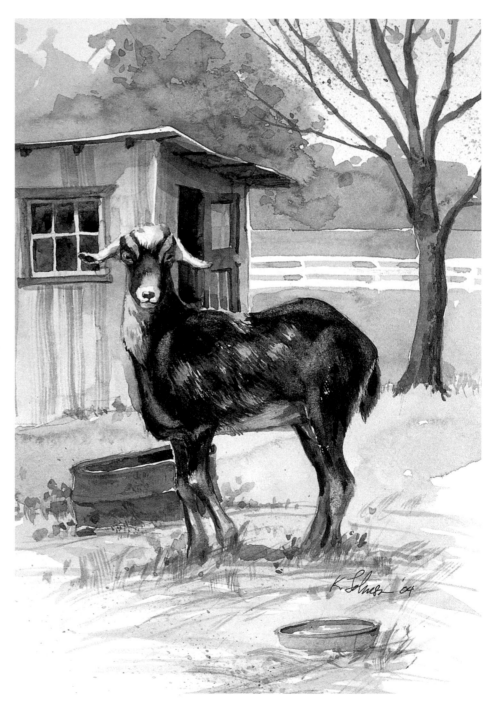

ARROWROCK GOAT
Watercolor
9" × 12" (23cm × 30cm)

Focus on the Eyes

Some artists enjoy painting every hair and whisker, and do it well indeed. I am not one of those artists. I find it more pleasing to simply suggest larger forms while focusing the viewer's attention with a few well-placed details. My method works in much the same way as the human eye: What we focus on appears in sharp detail, and everything around it looks softer and less detailed. I like to use that phenomenon to bring the attention to what I consider the center of interest.

Eyes catch our attention as nothing else does. That's why there are more illustrations of various eyes in this chapter than any other detail, by the way. Eyes are what we respond to first, what we "read" when we look at another living being. Even infants respond to a circle with two dots—the dots are perceived as eyes, and the baby looks right back! So it's important to focus on this most expressive feature, if you zero in on no other.

The Eyes Have It

The eye can tell us a great deal about the mood or condition of the animal. A cat's eye responds dramatically to light. The pupil expands and contracts in a rather extreme way in dim or strong light, more so than for dogs. The pupil will also alert you to what a cat is thinking. Right before a cat pounces, the pupil expands—fair warning!

It's important to notice the orientation or direction of the pupil, too. If you're painting a dog, the pupil should be round and probably rather diffuse-looking in that dark iris. (Pupils are much more noticeable in breeds with pale blue eyes—some huskies and English sheepdogs, for instance.)

Domestic felines have a vertical pupil, but goats and sheep have a horizontal pupil (see the illustrations below).

Eyes Change in Different Light

Draw a cat's eyes in different light conditions and notice how *very* different the results are. Make one drawing from the side and see how the dark pupil is set back and flattened.

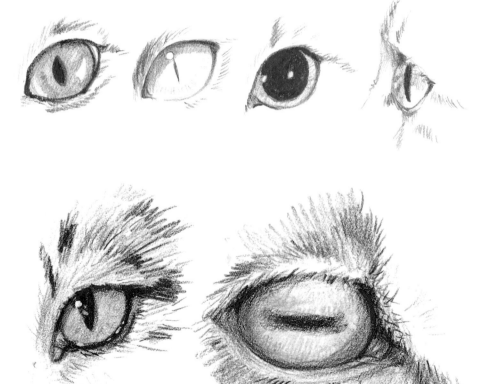

Detailing the Eye

Layering color works well to capture the details of the eye, especially in colored pencil or watercolor. If you have a good-sized collection of colors, layer until you reach the eye color you want. To achieve the illusion of roundness in the eyeball, use curved shadows and highlights.

For both the cat's eye (left) and goat's eye (right), I used Prismacolor pencils in various hues. I added Zinc White gouache to the cat's eye to create the sharp highlight. If you focus this tightly, pay attention to the direction of hair growth. Quick, lifting strokes suggest individual hairs.

Painting a Dog's Eye in Watercolor

Watercolor works very well for depicting the eyes of an animal. The combination of softness and crisp detail makes a very lifelike effect, as in this close-up of a dog's eye. To learn more about watercolor technique, refer to chapter six.

MATERIALS

PAPER
140-lb. (300gsm) watercolor paper

COLORS
Burnt Sienna • Burnt Umber • Cobalt Blue • Ivory Black • Ultramarine Blue

OTHER SUPPLIES
Gouache • No. 2 pencil • Paper towels

BRUSHES
Nos. 3, 5, 7 round • ½-inch (13mm) flat

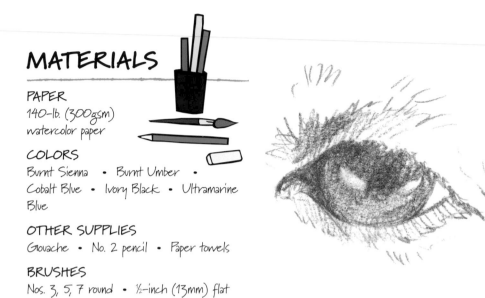

1 First, plan your subject in pencil. Pay attention to the roundness, the shape, the highlights, the values and the direction of hair growth.

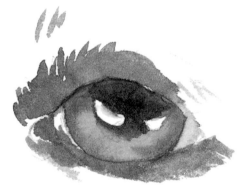

2 Burnt Sienna, Ultramarine Blue and Cobalt Blue work well to suggest a dog's eye. Lay in the first washes with your ½-inch (13mm) flat, using a combination of glazes and wet-in-wet washes (see pages 55). Paint around the highlights to preserve the white of the paper. The white of the eye is very seldom pure white, especially if it's in shadow, so use a watered-down wash of Cobalt Blue for the white of the eye and the shadows. Flood in some Cobalt Blue where the skin around the eye reflects the sky and to suggest shadows on white hairs.

Use a strong mix of Burnt Sienna with a little Cobalt Blue for the iris, wet-in-wet. Switch between your no. 7 and no. 5 rounds. At the top of the iris, paint a darker mix of Burnt Sienna and Cobalt Blue to suggest the shadows. Add a touch of this mixture around the sides of the iris for depth. When this color just begins to dry on the paper (it'll begin losing its shine), add a rich mixture of Burnt Sienna and Ultramarine Blue for the pupil. Because the area is still damp, it will remain a bit soft around the edge.

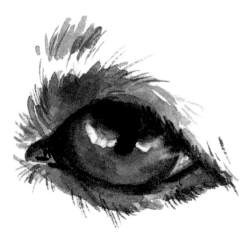

3 When the paint is thoroughly dry, add the darkest darks: a mixture of Burnt Sienna, Burnt Umber and Ultramarine Blue. If you want a stronger black in the pupil, use Ivory Black while the pupil is still damp so you will still have soft edges. Drybrush the hairs around the eye with a round brush that has a good point (a no. 3 round is good), and soften the highlights with a small brush moistened with clear water. Blot quickly with a paper towel to pick up the loosened pigment.

Using Details to Describe Your Subject

Details can be very telling because they're both distinct to species and to the individual. Often, the only way to identify something is by observing the details. Think of footprints in the snow. You can tell whether they belong to a dog, with its longer, more oval print, or a cat, with little round "flower" prints. You can identify raccoons, horses, deer—all sorts of creatures by that one distinctive detail.

The details also identify the breed within the larger species. A beagle's ears are very different from a Jack Russell terrier's, and they're different in turn from the shaggier breeds.

Dogs display a wider variety of these details than cats do, though there is variety within the different breeds there, too. It's just that the differences in dog breeds are more extreme! A shaggy toy Yorkie is really quite different from a stately, slender greyhound—more so than a Siamese cat is from an Angora, for instance.

On the Nose

Some dogs, such as hounds (beagles, bird dogs, Irish wolfhounds, greyhounds, mountain curs like the lovely Sarah that appears often in this book, etc.), have long, elegant noses, while others have... well, they call some dogs "pug nosed" for a reason!

Of course, different species have very different noses. Two little dots on the front of the face aren't going to tell you much about your subject. Generally speaking, a horse's nose is large, velvety and not as distinct from the rest of its face in terms of color or texture as those of some other animals. A dog's nose is usually rather rounded, but a cat's nose will fit roughly inside a little triangle.

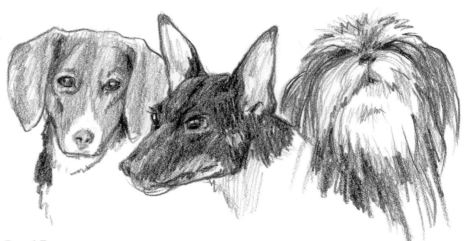

Dogs' Ears
A black Prismacolor pencil is a great sketching tool, used here to show the different types of dog ears. A hound's ears will usually flop down, some terriers' will stand at attention (as will a German shepherd's and others) and others are almost lost in their long, flowing hair, like this little fellow on the right.

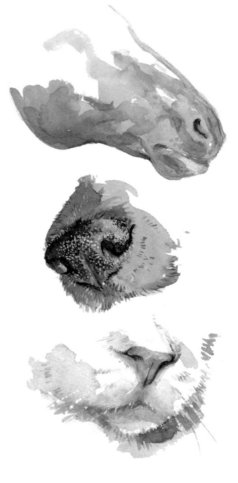

A Variety of Noses
All these noses were painted in watercolor with a no. 8 and a no. 5 round, using mostly combinations of Burnt Sienna and Ultramarine Blue. The cat's nose is a warmer pink, so I added a touch of Alizarin Crimson to the mix. Try different techniques for the details to find what you like best.

The horse's nose is a series of glazes and wet-in-wet washes.

The dog's nose makes extensive use of white gouache, an opaque watercolor that allows you to paint over a dark area for small details, rather than having to paint around them.

The highlights on the cat's nose, as well as the whiskers and some of the fur, were made by scratching through the wash once it dried.

Feet, Don't Fail Me Now!

It's not often that you would build a painting around an animal's feet, but if you get the shape or configuration off, it can be jarring—you can't always hide their feet in the tall grass! The shape of the foot and ankle, formed by the bones underneath, is a nice detail. It can show the motion or the mood, depending on its configuration; a lazy, drooping cat's foot expresses complete relaxation! The position of a horse's hoof will show whether it's standing at rest or in motion. And it wouldn't do to show a horse's hoof divided like a cow's or a deer's!

Notice the difference between the shape and configuration of a dog's foot and a cat's. Cats have retractable claws, their feet are rounder and the pads are generally softer than a dog's. The heel is larger and toes small by comparison. A dog's foot is slightly longer and somewhat more oval in shape, the toe pads are larger, and the claws extend beyond the end of the foot.

There are the same types of differences between the split-toed hooves of cattle, deer, goats, sheep, buffalo and other ungulates. Horses have a large, rounded hoof with an unbroken outline.

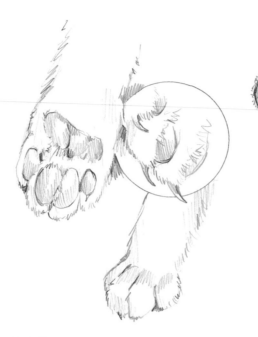

Cat's Foot

Sketch a cat's foot from various angles. Be sure to catch those retractable claws; pressing gently on the bottom of the foot will cause them to protrude from their protective sheath. Just be quick—the kitty might decide to use them!

Dog's Foot

A dog's foot is generally somewhat longer, with claws that extend at all times; their shape and position is important. Notice the difference in the configuration of the toes from that of the cat.

QUICK TIP

UNCOOPERATIVE SUBJECT?
If your subject refuses to cooperate long enough for you to sketch it, bring out the camera! Use the flash if the lighting is poor; it also helps sharpen details. My digital camera is invaluable for this type of resource material.

Putting the Details in Place

Sometimes it helps to make guidelines for ourselves to find the details within the shapes.

If you look at an animal's face straight on, you'll notice that it's symmetrical. When you start sketching the animal, draw a line dividing the face in half laterally. Next, find how far down from the top of the face the eyes are. Draw a horizontal line there; it should be quite straight. Use similar lines to place the mouth, nose and any other details you like, including how far apart the eyes are, how wide the nose is—whatever helps you really see your subject.

A quick guideline sketch will help you place details where they belong. Remember that like any other subject, creatures must conform to the rules of perspective and angle of sight, too. You're drawing a rounded object, not a flat one. When drawing a head from an angle, take the roundness of your subject into consideration. Your guideline that marks the lateral halfway mark of the face will be off-center, as well as curved to follow the shape of the skull. Depending on your perspective and whether the animal is looking up or down, the line that marks the location of the eyes might curve up or down as well, following the roundness of the head.

Perspective definitely affects positioning. Notice how much closer the eye farthest from us looks to the bridge of the nose, with the inner corner almost hidden.

It's All Relative

Notice relationships between features as you draw. For instance, the bottom part of a cat's eye (the more slanted angle) very often lines up with the cheekbone, no matter what position the head is in. If the cat is looking down or up, that line still mirrors the angle of the cheek.

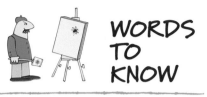

WORDS TO KNOW

PERSPECTIVE A technique for depicting scenes and objects so they appear to have depth and substance.

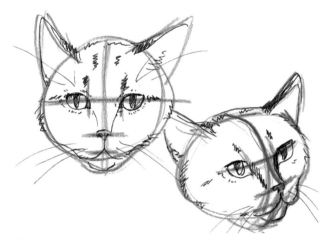

Placing Features Appropriately
The bold red pencil guidelines allow you to see where to place the eyes, nose and mouth in relation to each other. Notice how far down on the skull the eyes appear. Make a mark to guide you, then continue with the other details.

Echoed Lines
Here, the relationship between the bottom of the cat's eye and its cheekbone is emphasized with a bold black line.

Create Fur and Hair

Some animals are wonderfully sleek and shiny, and others have hair so long, they look like mops. Some have curly coats, others have very straight, stiff hair. There is a difference in texture between a dog's hair and a cat's fur, but that's difficult to depict unless you are really into painting the details! Practice capturing (or suggesting) the look of your subject with a variety of mediums. It makes all the difference, especially in those animals in which very little but hair is visible!

Choose two models to practice on, one sleek and the other hairy. Here, I've used Sarah, a friend's mountain cur, and the little furball that lives at the local antiques mall on Mondays. Mountain curs are often very brindled (brown and black hairs alternated in broken lines), but I only suggested that on Sarah's shoulders. Try a variety of techniques depending on the effect you are after. Pencil can make lovely hair-like marks, as can a fine-point ink pen. A watercolor brush used with a drybrush technique adds color to the illusion.

MATERIALS

BRUSHES
Nos. 3 and 8 round

WATERCOLORS
Burnt Sienna • Ivory Black • Raw Sienna • Ultramarine Blue

ACRYLICS
Titanium White

OTHER
water
pencil

1 For smooth hair like Sarah's, lay in an initial wash in the local color; it can be varied by adding a darker or cooler color as you paint. Allow that wash to dry, then add secondary washes to begin to show form and volume, roundness and shadows. Allow those smaller, darker washes to dry.

2 Use a fine brush or pinch the hairs of a round wash brush until they separate. Use just the tips to suggest individual hairs.

3 When everything is dry, use a stiffer brush dipped in clean water to lift highlights here and there to suggest the glossiness of the animal's coat. Pick up loosened pigment with a tissue.

4 Add as much detail as you want to get the point across. Here, I used more detail in the heads and fronts of my two models than toward the back, so you could see the progression.

1 For a shaggier, longer-haired animal, try the wet-in-wet technique. Once you've lightly sketched in the dog's form with pencil, wet your paper with clear water and lay in a variegated wash.

2 While that is still damp (but not puddling shiny-wet), add shading in darker values.

3 Allow that to dry, then add the suggestion of long hairs with a dry brush charged with pigment. Follow the direction of the hair, especially on the top of the head or around the mouth, and where the leg joins the body.

4 Let this layer dry thoroughly, and finish up with a few accent hairs with opaque watercolor or acrylic paint.

WORDS TO KNOW

LOCAL COLOR The actual color of an object, unaffected by shadows, lighting or atmosphere.

Capturing Life and Personality

People can make some really sweeping statements about the personality traits of animals: "Dogs are loving and loyal, but dumb," or "Cats are independent and aloof, but intelligent," or some variation on that theme. If you've owned either—or both—you know that such statements don't always apply. Each animal has its own personality. Some dogs are smart as whips, some run off at a moment's notice, some are mean and others will joyfully accept a snuggle from all and sundry. Some cats are as loving as any dog, full of affection and even empathy: One of mine would crawl into my lap and lick my face to comfort me when I cried! Some, bless their hearts, are dumb as a box of rocks, but lovable nevertheless.

What makes one animal a Personality Kid and another dignified as the Queen? Age, breed, health, weight and, yes, inborn inclination. Some cats are more affectionate and some remain skittish all their lives; I've seen both in a single litter, though raised exactly the same way. Some dogs wouldn't hurt a flea—literally!—and others snap at you if you look at them sideways.

Some animals are just full of energy and high spirits, even regardless of age. Take my cats, for example: Miss Pooh has just completed a wild, skidding run through the house for no discernable reason, and she's almost ten years old! My dear old Margaret Mary, on the other hand, used to pace slowly everywhere she went as if she were the Queen Mother passing by. Even as kittens, she and her sister Coyote were entirely different.

Right up into old age, Coyote would leap from a standing start to the top of a door jamb, leaving Margaret Mary staring up at her in amazement!

Those special personality traits that make each creature unique become a real challenge to capture on paper or canvas. This chapter provides some tips to help you meet the challenge. When we do catch something of that elusive personality—playful, intelligent, dignified, energetic, affectionate—it just plain feels good.

SILK-MANED MARE
Mixed media
7½" × 6" (19cm × 15cm)

Energy in Motion or Repose

The pose you choose to depict can suggest a lot. An elegant black cat in repose or a sleeping hound can invoke a serenity that's almost hypnotic. On the other hand, showing an animal in motion captures some of its energy and strength. I'll bet you can guess the age of the playful Labrador retriever pup (at right) with its air of mischief.

When sketching an animal in motion, use the gesture drawing technique. Move your whole arm, not just your fingers. Try for sweeping motions to create energetic lines. Work larger than normal, if it helps you to capture that effect.

Recently I attended a horse fair, where workhorses were plowing the earth using the most ancient of methods. No big John Deere tractors with their air-conditioned cabs and diesel fumes here! It was fascinating to see the strength of these great animals: the way they leaned into their work, the pull of muscle against mass. They were beautiful and powerful—and timeless, reminding me of the generations of farmers who made this land their own.

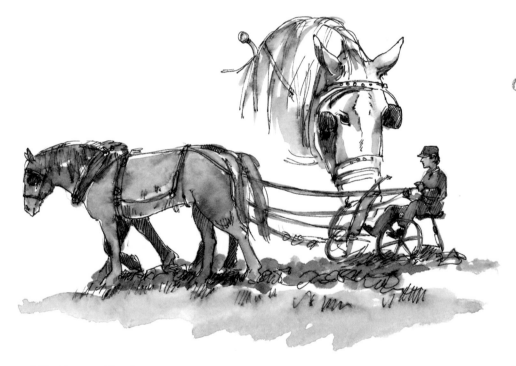

Workhorses Plowing
Nonpermanent (watersoluble) pens make great, energetic sketching tools. They're very versatile, allowing you to leave your sketch as a simple line drawing or alter it in various ways. You can moisten it with clear water on a brush (or with saliva on your finger, as I did on the right side of the large horse head sketch). You can do a watercolor wash to add a bit of subtle color. You can draw back into wet areas with your pen for softer lines, or wait until everything is dry and then restate the ink where you want crisper detail.

Be aware, however, that when you wet the lines, they will lift and blend in unexpected, lively ways—so don't expect total control! These horses were actually bay (warm brown) with pale manes, but the manes won't stay pale when you wet them with water unless you entirely leave out all detail. After the preliminary washes dry, the ink lines will be less likely to lift, so you can go in and add a bit more color here and there to adjust the value or hue.

Puppy Gesture Sketch
A quick gesture sketch, refined a bit later, caught this puppy at play. Do as many versions on your page as you have room or time for. You're bound to capture something of that mischievous personality.

Capturing an Animal's Mood and Personality

This is really no different from capturing the personality or mood of a person in your work; like people, animals convey their dispositions through their expressions, stances and movements. It's very easy to tell the difference between an old mutt who is everyone's friend, a dignified show dog and a "junkyard dog" that's ready to take your arm off if you trespass on his territory. (You're not all that likely to stick around and paint the latter, of course!)

A happy, friendly animal almost grins at you! Dogs wag their tails and their tongues hang out in big smiles. They hop around as if their feet had springs. A frightened dog may grovel and whine, tail between its legs and chest to the ground. A territorial animal may have a ridge of fur raised all the way from its neck to its tail, and will advance, stiff-legged. Frightened or angry animals are best observed from a distance. We have a pair of large black dogs in our neighborhood that seem to be quite aggressive, and I'm glad I've observed them going into their territorial act only from the safety of my own front porch!

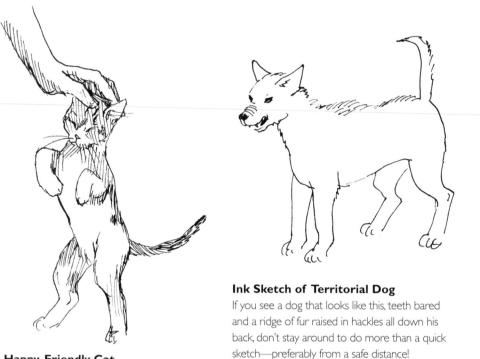

A Happy, Friendly Cat
My Scoutie-cat waits outside my bedroom door for me to get up in the morning (I swear she can hear my eyes open!), then stands on her hind legs for me to pet her on the head.

Ink Sketch of Territorial Dog
If you see a dog that looks like this, teeth bared and a ridge of fur raised in hackles all down his back, don't stay around to do more than a quick sketch—preferably from a safe distance!

English Sheepdog
Colored pencils work well for this sketch of Winston, the English sheepdog. Watercolor pencil blends in the shadows when you touch it with clean water. Try to follow the direction of the hair with your strokes. Take your time on the eyes.

Format may help convey mood or character, even somewhat subliminally. A horizontal or *landscape* format can reinforce a serene, restful, calm mood. A vertical or *portrait* format may offer a more active, energetic or dramatic feel. Explore both in thumbnail sketches to see which better suits your composition and the mood you are trying to create.

Thumbnail Sketches
I liked these playful kittens swarming around my husband's feet so much, they ended up as a painting. The vertical format worked best in my mind; I loved the contrast of my husband's tall, skinny legs and the tiny kittens at his feet.

Reference Photo
This is a good example of editing to focus on what you want as an artist. One advantage we have over photographers is that we can edit out anything we don't want without computers and Photoshop!

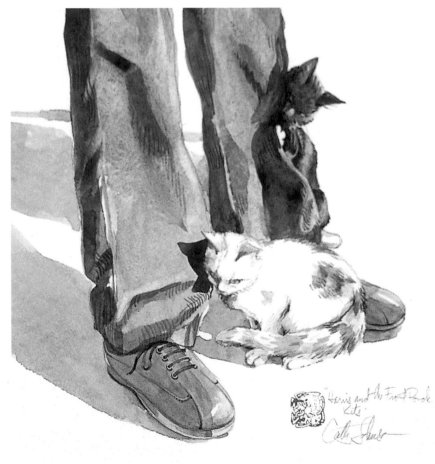

WORDS TO KNOW

THUMBNAIL This type of sketch is very small and is used to capture the composition of an image, not the detail.

Harris and the Kittens
I like the almost oriental feel of white paper, so I left out all the details of porch floor and house wall to zero in on my subject. To add to the Asian ambience, I used a Celtic knot as my own variation on the chop mark.

Playful Pups

Even in repose, a pup looks very different from a full-grown dog. Their heads are rounder and their ears are smaller. Their eyes are larger in comparison to the skull than those of an adult animal—once those eyes are open, of course. Puppy noses may appear disproportionately large, but the pups grow into them!

Once they begin to take food instead of mother's milk, pups become quite adventurous and active. They love to play—with you, with their littermates, with a chewtoy, with your shoe! This is a good time to utilize gesture drawing and memory sketches (see chapter two). These will give you a very good sense of how a puppy moves. You may not be able to do fully realized drawings of a young animals from life because they're always in motion, except while sleeping. For that reason, you may find it useful to take a series of resource photos. Use a fast speed to freeze action poses, then combine them with your gesture sketches and studies of a sleeping pup to create as detailed a painting as you like.

QUICK TIP

PUPPY EYES Most puppies will develop brown eyes: either a very deep, dark chocolate, or a wonderful rich burnt sienna. A few, like some huskies, may have one brown and one blue eye, and a few, like my friend Winston on page 88, have ice-blue, almost white eyes.

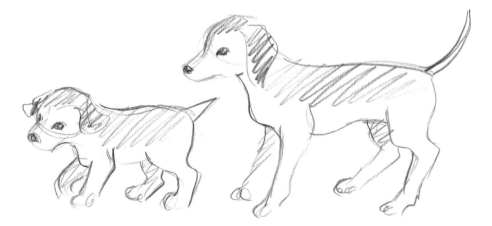

Puppy Proportions
A very young pup has short legs and relatively large feet in comparison to his body. His head is also much larger in proportion to his body than that of an adult dog. Proper proportioning is one way you can suggest an animal's age in your work.

Young and Mature Beagles
Look at the differences between the young beagle puppy and the full-grown dog in this watercolor. The puppy's muzzle is shorter and more rounded, as are the ears. The eyes and nose are bigger in proportion to the face.

Kinetic Kittens

It almost seems to me as if kittens are even more playful than pups, and I've lived with plenty of both! When kittens are awake, they're in constant motion. Even when they're feeding, they jockey for position and squirm and knead.

Like most mammals, cats are born with eyes tightly shut; they open a little at a time after a week or ten days, revealing milky blue irises that will develop adult coloring later. Grown cats may have green, amber, yellow or blue eyes.

Kittens begin to explore as soon as they are weaned, even though their weak, tiny legs are barely able to hold them up and their fat little bellies seem to swim over the floor with amazing speed!

If you have a kitten that's just becoming active, you will need to work fast. Do the preliminary sketch lightly in pencil, just to catch the pose or shape. Then you can develop it, adding ink or even watercolor washes to capture the particular animal.

Never throw away even the roughest sketch, even if you're not satisfied with it at all. You may have caught just that detail or fragment of a pose that you'll need later.

As with puppies, you may fare best here by working from a combination of gesture sketches and studies, and any photographs you've managed to take of kittens at play.

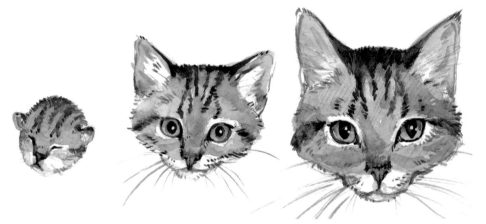

Kitten to Cat

Observe the changes that occur in the kitten-to-cat progression. A baby kitten's head is much more oval-looking since the skull is not yet fully formed or hardened. The ears aren't fully developed either; kittens' ears appear lower on the head and become more prominent as a feline ages. Even after kittens' eyes develop their adult color, the iris in a younger cat's eyes appears softer than in a full-grown animal. Like a puppy, a kitten's head and feet are larger in proportion to its body than an adult cat's. Their noses don't look quite as out of proportion as the rest of the head grows. A grown cat's muzzle is more prominent, except in some breeds such as Persians, where the face is somewhat flattened.

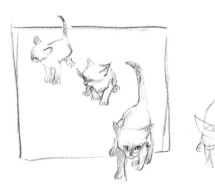

Capturing Kinetic Energy

This is when you really have to move fast! Gesture drawing and memory sketches work well to capture those kinetic kittens. The gesture sketch above shows how much you can expect to catch.

Resort to a photo for the details if you need to, but try to draw what you see, not what you know. That will help you capture the energy of your subject.

The Alpha Male Kitten

Many litters of kittens have an alpha male. This one practiced his territorial threats on me, arching his back and puffing out his fur to make himself appear bigger. I quickly sketched the "menacing" pose and then created an ink and watercolor painting.

Cats and Dogs, the Grown-Up Variety

Once they are fully grown, animals usually change very little. Older animals may develop a weight problem or become more angular with truly advanced age, but for the most part, their configuration remains relatively stable over the years. Until a muzzle gets gray or the fur begins to get spiky as skin tone is lost (more frequently seen in elderly cats), it's difficult to tell an animal's age.

There is still a great deal of variety to portray, however. Distinctions among cat breeds are not so pronounced, though there are obvious differences between a Maine coon cat and a Siamese, a long-haired pedigreed Persian and a backyard moggy with sleek short hair.

Still, various breeds of cats are more similar in overall size and weight than are dog breeds. There, you will find a huge range in size, from tiny Chi-

huahua or other miniature breeds to, say, mastiffs. Some dogs, like Yorkshire terriers, have such long hair they look like dust mops made of silk, while others are as smooth and sculpted as a greyhound. There are enough types to keep you busy drawing dogs for some time to come!

Cat Shapes
These are only a few of the silhouettes of various types of cats. Though a Pekinese-faced Persian is definitely different in appearance from a Siamese, unlike many dog breeds, they're roughly similar in size.

Dog Breeds
These ink drawings of dog shapes and sizes show an amazing variety. From left to right, a Chihuahua, a beagle, an English bulldog, a collie, and an Irish wolfhound. The size differential is much more exaggerated in real life, I'm afraid!

Venerable Age

Some dogs, when they become aged, develop a certain patient look on their faces that is wonderful to try to capture. Their muzzles are grayed, their eyes knowing. They also have a special dignity.

QUICK TiP

DOG YEARS The old saying about a dog's age being equal to seven human years is not entirely accurate. A dog's age in human years depends a lot on the weight of the animal! A five-year-old 20-lb. (9kg) dog is about 36 human years old. A five year-old 90-lb. (41kg) dog is about 42 human years old. So, smaller breeds "age" better!

Old Dog in Colored Pencil

You can portray an old dog by keeping his body either a bit more angular or sturdier than it really should be. I remember that a friend's ancient border collie had a very broad backside! On older dogs, the fur may be spikier, and the hair around the muzzle and eyes is often white or grizzled, as shown on this ancient hound.

Ink Sketch of an Old Hound

Pigma Micron pens make wonderful sketching tools for capturing your subject in a quick, clean, crisp fashion. This old hound was quickly drawn, but the sketch reflects something of his patience and endurance nonetheless.

Goats and Sheep

Unless you live in the country, you'll probably need to visit a working farm or a petting zoo to see these larger creatures in person. I'm fortunate to live in a small town, so "country" is about six blocks away, but if you need to take a research trip, it's well worth the effort. Take your sketchbook and your camera. If you like working on site, take your painting gear and a lunch, too. (Don't forget sunscreen and insect repellent!)

Goats and sheep make particularly good subjects, both close-up and at a distance. Their personalities are really quite different. Goats are very often curious, affectionate, playful and adventurous. (I still remember my cousin's goats climbing to the second floor of the abandoned house on their property and leaping out the window like mountain goats—repeatedly! For them, it was a game.) Lambs are playful, of course, but grown sheep tend to be more placid, so that's how I paint them.

Sheep sometimes look like big fuzzy balls with legs, particularly before shearing time in the spring. Though we imagine them to be mostly white, you will find that they are generally shades of cream, tan or gray, and even black—just like in fairy tales.

There are many breeds. They may have long or short fleece, and their heads may be smooth or covered with curly fleece like the rest of their bodies, usually with at least the muzzle and nose smooth. Some breeds have horns, and some have black faces and ears, as well as dark-colored lower legs. Others, like the small flock at Watkins Woolen Mill State Park and State Historic Site in Missouri, are Cotswolds and merinos, with faces the same color as their fleece.

Details help differentiate one from another when you paint a whole flock together. Close up, sheep are as individual as any other animal. They may have great dignity, or look as curious as a kitten. If you get the opportunity to sketch lambs in the spring, by all means do so! They are among the most adorable of nature's young animals.

A goat has a body configured like that of a dog or deer. Though goats don't really qualify as "large" animals, they are wonderful subjects: inquisitive, energetic and funny. Pygmy goats are very popular. They're smaller and stockier in build than some of the larger breeds, such as Toggenburgs or Nubians.

In configuration, goats have much in common with deer and dogs; in other words, their body shape is much the same.

Middle-Distance Sheep
This is one of the black-faced breeds, obviously! To suggest sheep in the middle distance with acrylics, make a blob of white paint on toned paper. Add black legs, face, tail and ears in logical places. Finally, model the sheep a bit with shadows on the underside of the sheep and on the ground below.

Herd of Sheep
To suggest a whole herd of sheep, make a series of splotches of white or light-colored paint in varying sizes. You can suggest the terrain by how you place these spots. Keep smaller daubs in the background and larger ones closer. Add legs, heads, etc., but just suggest them on the animals farther away. If the herd is in the distance, it won't be necessary to do more than suggest details.

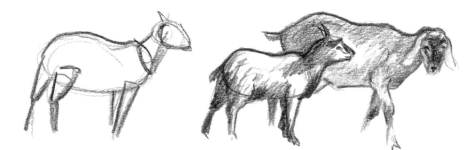

Nubian and Pygmy Goats
Notice the overall configuration of these animals. Sketch in the basic shape with simple guidelines, like the pygmy goat on the far left, then develop it further to finish. The regular-sized goat on the right is a Nubian.

Sheep Portrait in Acrylic

Sheep can be a lot of fun to paint up close. The curly, textured wool allows you to play with color and technique. I enjoyed varying my brushstrokes as I painted this study of a sheep's head. I chose to paint on sturdy watercolor paper, but you may prefer something more durable, like canvas or Masonite.

MATERIALS

PAPER
300-lb. (640gsm) watercolor paper

BRUSHES
Nos. 3 and 8 round • ½-inch (13mm) flat

PAINTS
Burnt Sienna • Cobalt Blue • Hooker's Green • Ivory Black • Olive Green • Payne's Gray • Raw Sienna • Titanium White • Warm White

OTHER
Paper towels • Spray bottle • Light-toned colored pencil (optional)

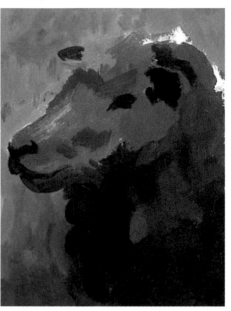

1 Begin by painting around your sheep, using a mix of Hooker's Green and Olive Green. Let the background have some variation to suggest distance. One way to do this is by lightening the mixture with Warm White.

2 Lay in the dark colors that will suggest the depth of the fleece and the shadows. Use mixtures made with Burnt Sienna, Raw Sienna, Cobalt Blue and Payne's Gray. Use the drybrush technique to model the sheep's muzzle.

3 Use a variety of strokes to suggest the wooly fleece, using lighter values—but *not* all white! Vary the color with Titanium White, Warm White and Cobalt Blue. Let your brush dance over the surface of the paper. Lay lighter colors over dark ones when using an opaque medium like gouache, acrylics or oils.

Finish the details and develop your sheep as much or as little as you want. You can use a light-toned colored pencil for some details, if you like.

Horses

What kid doesn't want a horse at some point? (I promised my dad I'd keep it in my room and clean up after it!) Needless to say, most of us never get our wish, but we can paint the lovely things and that's almost more fun. (Not so much work and expense, either!)

There are many kinds of horses: riding horses, workhorses and everything in between. They may be sleek and beautiful, or shaggy, stocky and incredibly strong. They can be peaceful, grazing in their fields like great sentient statues, or they can suddenly decide to race from one end of the paddock to the other!

Notice the configuration of the animal you are trying to draw. There is a great deal of difference between a powerful workhorse like a Percheron and a slender riding horse such as an Arabian or Appaloosa. Note the relative musculature, the length and breadth of the neck, the muscular chest and the size of the feet in a workhorse.

QUICK TiP

HORSE TYPES To learn the differences between race horses, working horses and riding horses, try to find resource photos of all three types in roughly the same pose.

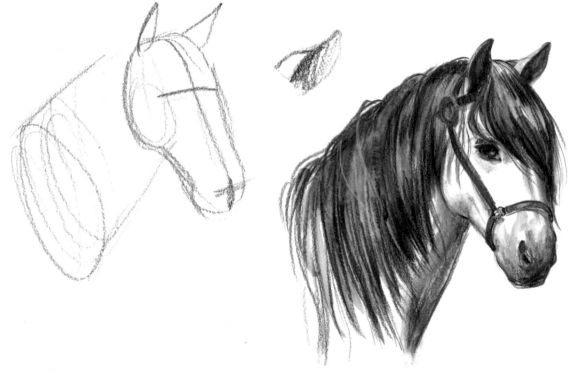

Horse Portrait in Mixed Media

If you want, first sketch the horse using simplified forms. Remember that the neck is a flattened cylinder with roundness and volume; use ovals within your sketch to capture that. Notice the roundness of the cheek and the angle of the nose as you sketch in the center line of the head—which isn't in the center from this angle. Use horizontal lines to hep you place the eyes and nostrils, and remember that the skull is also rounded. This will give you a rough idea to follow. Don't worry if it's not perfect; the sketch is intended to be a loosening-up and visualizing exercise.

Lightly sketch the shape you've decided on, then lay in colors with watercolor pencil. Don't try to do a complete drawing and then wet the whole thing: Work in layers or stages instead, allowing the penciled washes to dry between layers. Continue to mold the form, tweaking as necessary. (Near the base of the neck you can see pencil marks untouched by water.)

Don't feel trapped or constrained by your original choice of medium; there are no boundaries! If you feel the need, add ink lines or non-water-soluble colored pencil to darken or strengthen areas. Working with mixed media can provide wonderful results, as long as the mediums you've chosen are compatible. Here, the mane and other details received both ink and wax-based colored pencil, and lights were added with a white colored pencil. A bit of red colored pencil was added to the cockade to make it pop.

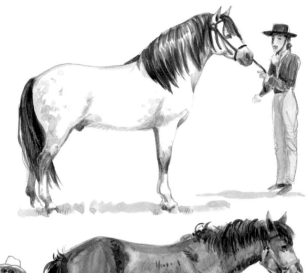

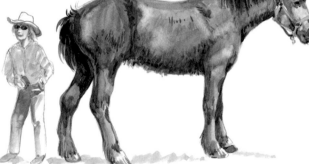

Watercolor Studies of Two Horses

Notice the differences in these two types of horses. The lovely riding horse has slender, elegant legs, a longer neck, and a long mane and tail. Its muscles are smoother, as well. The workhorse shown here is a Percheron. This particular animal is very tall and long-legged. Its legs are powerful, and much thicker than the riding horse's. Its neck is shorter in proportion to the rest of its body, and it doesn't hold its head as proudly. It's also still wearing the last of its winter coat, so it's a bit shaggy!

The relative height of these two breeds is amazing—look how much taller the workhorse is. Granted, the rider in the lovely South American gaucho outfit is taller than the young cowgirl in jeans, but trust me, the Percherons are big animals!

Try watercolor on smooth bristol paper like this; washes go on crisp and somewhat edgy, but they also lift in interesting ways if you want to reclaim highlights, as on the workhorse's muscles. Allow the wash to dry, then lift out lights with clean water on a brush. Blot quickly with a tissue.

Foal

Notice the different configuration between a foal and a fully grown horse. The foal has a shorter mane, a shorter tail and a shorter neck and body, but the legs are extremely long.

Cattle

Cattle—bulls, cows, steers—make wonderful subjects for a painting, giving it a particularly pastoral look. Some artists have built their reputations with paintings of the great Western herds being driven by cowboys or dramatically stampeding, but most of us will have to be content with the calmer aspects.

You may find it difficult to get close to these large animals, and sometimes that's just as well. They can be temperamental and might hurt you without meaning to, so always play it safe. Work on the other side of the fence unless you know the particular animal and have permission from its owner. Don't make threatening or aggressive gestures or trespass on their territory. Bulls seem to take this as a personal offense!

Still, they do make wonderful subjects for paintings or drawings. I once got in a corral with a young bull to get the best possible photos to work from, for a commission from the bull's owner. The bull was beautiful, but I couldn't get the shots I needed from the other side of iron bars. *Do* be sure you know what you're doing if you try this, however. The owner was present and assured me this particular animal was very docile, or I would never have done it, and despite the assurances, I made my visit on his side of the bars as brief as possible!

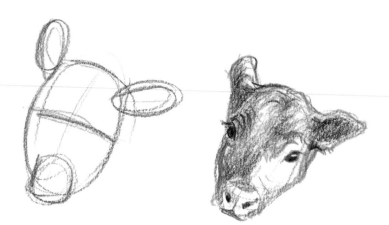

Cow Head
Sketch a steer or cow face in the medium of your choice. If you like, lightly sketch in guidelines first for placing the eyes and the center of the head. Then add details, developing your drawing as much or as little as you like.

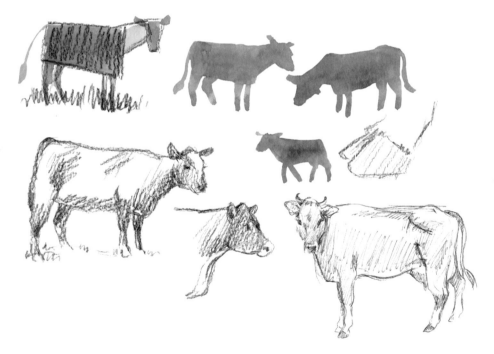

Overall Body Shapes of Cattle
It may help to break down what you see into geometric elements, as shown in the multicolored cartoon.

The sketch of the three little Burnt Sienna cattle relies on the same concept, except it was done with a flat watercolor brush without preliminary drawing. Developed a bit further, the sketch would work fine in the middle distance of a finished painting; just add shadows for volume.

And finally, at the bottom are more fully realized sketches of various bovines: a couple of Angus steers done with a black Prismacolor pencil and a Jersey cow sketched with a black ballpoint pen. Try the different mediums until you find what suits you best.

Birds

Most birds are incredibly alert and energetic. Even when perched and seemingly in repose, nothing escapes their notice for long. They cock their heads and regard you with unblinking eyes.

If you have a pet mynah, parakeet, finch or parrot, you have a live-in model, ready to pose on the spot. Wild birds at your feeder are wonderful sketching subjects, too. Learn which birds prefer what kind of feed and you can attract models from hummingbirds to woodpeckers. Some wild birds are in fact so used to humans, you can draw and paint them at your leisure. Think of that flock of pigeons in the park, or gulls as they cluster around an ocean fishing dock.

Of course, if you're interested in wildlife art, remember that the gestures and appearance of a creature in temporary captivity are likely not quite the same as they would be in the wild. Nothing replaces time in the field, observing from life, but being able to get photos and drawings close-up is invaluable.

If you decide to do a portrait of a bird, pay close attention to the eyes, beak and pattern of the feathers. That's what will identify the particular creature.

Distant Birds

Try a variety of ways to suggest birds in the distance. Some artists use a conventional V-shape (the blue shapes); others prefer the loose X that can also suggest the head and body (the red shapes). Use your brush in different ways. Birds that are a bit closer benefit from being carefully drawn with your brush.

Backyard Visitors

The bird at the top left is a male cardinal. The bird at the top right is a quizzical blue jay standing in the snow. The largest bird is a chickadee. The chickadees in my backyard let me come so close I can almost touch them.

QUICK TIP

NATURE SANCTUARIES

Volunteer at a nature sanctuary. You'll have hundreds of opportunities to get close to wild birds (or other animals) that you'd never have any other way of meeting. Some of my favorite paintings are portraits of birds rescued and rehabilitated by my friend and veterinarian Pete Rucker.

SEABIRDS

Seascape With Waders

Many artists put birds in their landscapes to add a sense of life and motion. A seashore scene almost looks incomplete without gulls, waders or maybe even a pelican. Distant shapes can be fairly simple, but try to depict those in the foreground as accurately as possible.

Subject Matter Resources

Putting all this together is great fun as all these bits and pieces become the basis for your finished paintings. You'll be amazed at how the things you've picked up will find a use, one way or another. Gesture sketches will help you capture the essence of something you might otherwise not have attempted, and give you confidence and spontaneity in your drawing as well. The negative spaces around your subject will help you draw it more accurately, but also provide an interesting new rhythm in your composition.

The way you use your resource photos now will go far beyond simple copying—they're a jumping-off point, an inspiration, a true reference for details or mood.

Explore some of the things you can do with what you've learned! Paint better than ever before with techniques you've been practicing, or let your imagination out to play and put your pets into situations they've never been in. Art is supposed to be fun, as well as a means of communication and self-expression.

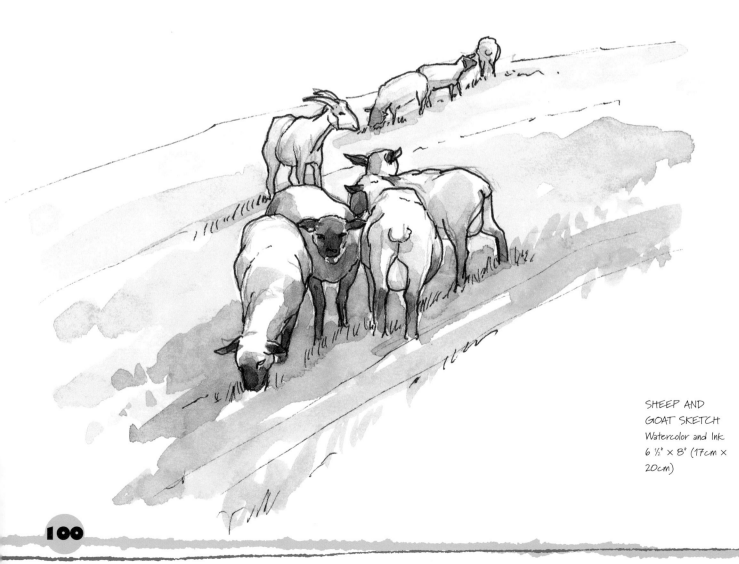

SHEEP AND
GOAT SKETCH
Watercolor and Ink
6 ½" × 8" (17cm ×
20cm)

Photo Opportunities

Carry a camera whenever you go for a walk or drive. It needn't be a large, bulky professional model; I've gotten lots of good resource photos using an unobtrusive pocket-sized camera with a zoom/wide-angle lens built in. Digital cameras are wonderfully affordable now. You'll be happiest with 1.3 mega pixel or better. My Olympus is a 1.3 with 3X zoom, and my Kodak is 4 mega pixel. Professional models go above those numbers, of course, but cost a good deal more.

Be aware that the sound of the shutter on a nondigital camera may scare off your subject, so make sure you have the picture you want framed in the viewfinder before you snap that picture! Birds and wild mammals are more skittish than domestic creatures, of course. You may find a sheep staring right back at you over the fence as if to ask what you're doing there.

If at all possible, ask permission before shooting photos on a farmer's land. Close gates securely behind you if you find it necessary to go into a pen or corral. And no matter how preoccupied that huge pig looks, don't be tempted to get too close; pigs can be quite testy, especially boars and sows with piglets. Goats may just want to play, but if they butt you, it hurts. Even if they have no horns, stay out of their way.

Whether or not you are looking for a specific animal, keep that camera handy.

You never know what you'll be lucky enough to find in your travels, no matter how close to home. I have a file of animal photographs (and one of birds as well) that nearly fills an entire shoe box.

When I need information on overall shape, musculature, coloring or a specific pose, I generally can find something among my own reference materials to help me out.

Reference Photos
I like to have a wide variety of reference photos on hand so I can sketch whatever I like, whenever I like.

Using Photographic References

Some artists look down their noses at photographic references, but as long as we are not trapped into trying to reproduce exactly what we see (after all, the camera already *did* that!), reference photos can be very useful. As we use them to plan our artwork, we can tweak the composition, edit, combine, change hue or temperature, abstract the subject or zero in on a single detail. A photo is just a useful tool, not a taskmaster.

I once combined a photo of a barn in a bare winter landscape with a photo of a herd of sheep in summer. Then I threw in an imaginary snowstorm, ending up with one of my favorite paintings. We can pick and choose details; we're artists!

What and How to Shoot

Shooting photos of animals or birds in full sun doesn't yield the most satisfactory results. The shadows look almost black and obscure a lot of information you will wish you had when you begin to plan your painting. Often, the image is too broken up, like a jigsaw puzzle with only light and dark pieces. When shooting outdoors, try to shoot on overcast days or in the shade for detail photos. Morning and evening provide the most interesting lighting situations; high noon is definitely not the optimum time to shoot.

Indoors, use a flash if you absolutely have to, but be aware that it will make the animal's eyes shine eerily and throw unnatural shadows around its form, almost as if your subject were outlined in black. For our purposes, this is *not* good; it's too distracting, and the artificial light flattens out the natural shadows that define form and volume. (Outdoors in full sun, however, a bit of filler flash may help balance that stark light-and-deep-shadow effect.)

Different Lighting Conditions

Notice how the shadows define the shapes. You may have a pool of deep shadow directly underfoot at high noon, or a nicely rim-lit shape in the long-raking light of late afternoon. The colors are often richer then, too.

Picking and Choosing

I used a variety of reference photos to come up with this initial sketch. I decided to use the puppy in the very top left with the seated sheepdog on the right (except I flipped the seated sheepdog).

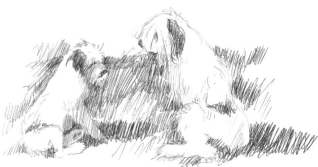

Digital vs. Conventional

Good old 35mm cameras are still marvelous, especially SLR or through-the-lens models, where what you see through the viewfinder is basically what you get. Not only can you focus, but you can zoom and set your own exposure as well.

Digital cameras have made photography much easier in many ways: you can download the photo to your computer, crop out what you don't want, adjust the lighting, sharpness and color temperature, and then size it to whatever you need. Don't try to reduce the size much below six hundred pixels if you want to print a hard copy for details, though, or it will be fuzzy or too broken up. If you don't have a color printer (I'm still in the dark ages), you can transfer your photos to a CD or diskette and take them to a commercial print.

Get the best possible photo to begin with, *then* tweak it. Use the adjustments on a conventional camera as much as possible; if it's too dark through the lens, the resulting photo will be too dark as well. Some photo-editing software programs will let you modify a too-dark photo to an extent, brightening or sharpening an image. If you own a scanner, you can scan hard copies of photos and then tweak them with software as you would a digital photo. I have one program that came with my scanner, one that came with my digital camera and a relatively simple but powerful photo-editing program (Photoshop Elements 2.0), and use them all at one time or another for different tasks.

Many artists consider computer-tweaking to be a new form of sketching, and why not? You can combine a number of images to explore new compositions, move or delete objects, change images around and even flip or distort them. If you are computer literate, or have invested in photo-editing software, explore these possibilities. I still find it faster and just plain more satisfying to do it hands-on with a pen or pencil and a piece of paper if I'm doing more than simple cropping and adjusting contrast—but I'm probably dating myself!

What should you photograph? Anything that inspires you! Animals in the zoo, domestic chickens, waterfowl, herons or gulls, burros in Nevada, the wild horses of Chincoteague Island, birds at your feeder, your own dog or cat or hamster... whatever speaks to you, whatever would make a good painting and whatever communicates best to your viewers.

QUICK TIP

COPYRIGHT Copyright issues are a very big concern. If you work from photo resources, be sure you either took them yourself or have permission to use them in your art. "Fair use" is tricky to interpret, and, generally speaking, if any part of someone else's art—read "photo," in this case—is recognizable in your work, it's too much. That applies even if you're making a new work in a different medium and you're not using their photo directly, as you might in a collage; even working from someone else's photo comes under this law.

In any case, I prefer to work from my own photos rather than someone else's, not only because of copyright considerations, but because this way I have a greater, more personal understanding of the animal.

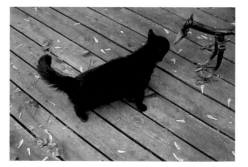 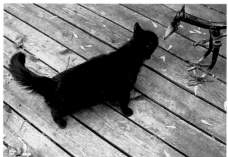

Using Your Computer to Make Changes
Here are a few examples of untweaked and tweaked resource photos. The changes I made to the photo on the left using the computer were really basic, just cropping and lightening the image.

How to Edit Your Photos

Combining resources often results in just what you're after, whether that be a more pleasing composition, more accurate details or a more powerful painting. Still, you should be aware of the pitfalls and challenges of blending as you put these disparate images together in a new context.

The guidelines for composition, value and color that apply to drawing and painting apply to photo-editing, too. Remember perspective when combining images from different resource photos. If you place a herd of sheep from one photo into a new context, make sure the position of the animals agrees with the terrain. If they were on a hill or incline, the new setting needs to have the same basic incline. Of course, that's fairly simple to indicate with shadows or other details, but being aware of the possible need to make adjustments is half the battle.

Also remember the direction the light is coming from, as well as the type of light. If strong shadows from afternoon light are falling across your subject, remember that the new landscape needs the same type of shadows. If your original photo was taken on an overcast day when shadows are not so extreme, everything in the new composition should be similarly muted.

You may find it quicker and easier, as I do, to edit with a pencil (you're just planning, after all, not making a finished piece of art). Try several sketches using these photo references to see how their elements work best together.

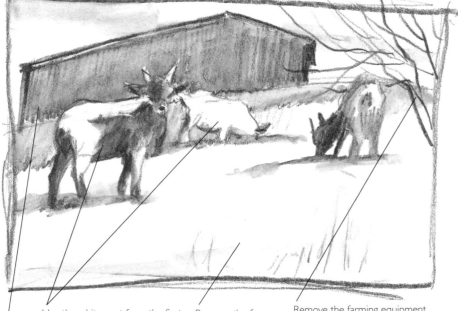

Reference Photos
Pick and choose which elements you plan to use, and then do a rough sketch to see how you can make them work in your planned composition.

Use the white goat from the first photo. Use the brown foreground goat from the second photo.

Remove the fence post and wire fence.

Remove the farming equipment. Emphasize branches.

Push the barn back.

Animals Close-Up

It's often much much easier to get good resource material with a camera than by trying to get close enough to an animal to sketch it. Many animals in the wild are unused to humans or distrustful of us and won't let us get close enough for sketching. Even farm animals may be wary of strangers, and some, like the bull I described in the last chapter, might be downright dangerous. A tele-photo lens or zoom feature on your 35mm or digital camera can help a great deal with this. Keep a comfortable distance, and use the zoom to get in close.

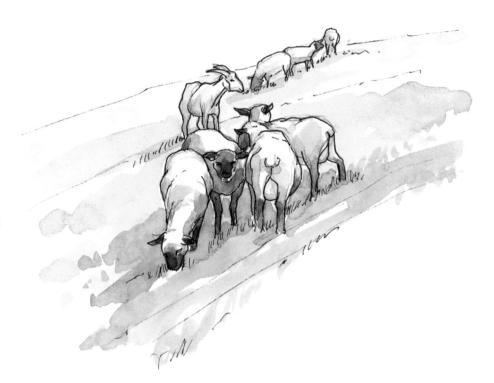

Using Animals in a Landscape
Notice how this sketch of sheep on a hillside makes use of shadow and pose to suggest the shape of the land. It's a more dynamic handling than a flatter landscape.

Resource Photos of a Bull
It's sometimes best to get close-ups with a zoom lens. These animals are not in a petting zoo!

Let Your Imagination Come Out to Play

It isn't necessary to paint exactly what you see. You can move a flock of sheep or a heron into a new locale if you want, but you can also break out of the bounds of reality. Imagination is great fun, and it stretches your creative muscles as well.

Painting Animals in Unorthodox Situations

You can put your pets in situations they are *never* going to be in: Think of the famous print of the dogs playing poker. When I lived on a farm, I had so many cats, I used to fantasize about putting them to work. (I still do: This book attests to that! They're paying their way as models, and their fee is only a good rub and a can of tuna.)

Go with those fantasies and paint whatever you like!

Beyond Reality

You can paint dragons, unicorns, stick-creatures, whatever you like, utilizing real animals as your models. A dragon is not so very different from some lizards—at least, the dragons I "see" are not. You can use the skeletal formation, musculature and even scale patterns of many reptiles to depict the dragon you envision. Or use dinosaurs as your inspiration. Your creation can be realistic and believable if you follow the form or function of smaller, more common animals or creatures in the fossil record. Or combine characteristics of, say, a chameleon and a snake, or a pterodactyl and a crocodile. Then let your imagination carry you just that bit further!

You can also go beyond the built-in logic of basing a dragon on a lizard, or a unicorn on a deer (which is much more like a unicorn than a horse, in my estimation). Some imaginary creatures may be no more than a semilogical collection of sticks and leaves. I explored that option and several others before deciding on the little dragon at right. The original resource photo was of my friend Susan and a beagle, but I decided to branch out and make her "pet" a bit more exotic!

Let your imagination soar. Once you understand the basics of body configuration and what is possible vs. impossible, you can create whatever creatures you like—and have a ball doing it.

Painting Your Fondest Wishes
I put my cats to work in this series. This cat is operating my little antique washing machine. I also painted a cat chopping wood.

A Dragon From Many Sources
If you understand how living creatures are constructed and how they work, you can extrapolate to make fantastical animals from your own imagination. This dragon is a combination of bird claws, a dog's body and head, a giraffe's neck and a bat's wings.

Susan and Her Beagle
This inspiring resource photo encouraged me to let my imagination run free.

Susan Faerie and Her Baby Dragon
Let your subject and your muse guide you. You may have planned an ink and watercolor sketch, an acrylic painting or a mixed-media work. If, as you work, a silvery graphite study on smooth bristol paper captures your imagination, stop there—no need to go further! The sky's the only limit.

From Beagle to Fairy Stick Creature to Dragon
Experiment with what your unearthly little creature might look like. Go as far to the edge as you can, following a logical direction.

Conclusion

You've explored the basics of composition and color, tried a variety of techniques and mediums, and by now you have a pretty good idea what feels right and good to you, how to get the shapes and colors and details you want.

Capturing the texture of an animal's fur is no longer a mystery; though always a challenge, no getting bored here! You know how to get the look of life in those eyes and create the excitement of feeling them looking back at you. Hopefully, you've created some works you really like, you've developed your own creative "vocabulary" and you know where you want to go from here.

So what's stopping you? Head off down that road, and most important of all, *enjoy!*

Glossary

Back runs. An uneven and unintended splotch caused by water or wet paint that has leaked back into an area of the painting.

Bloom. A white haze that appears on colored-pencil pictures.

Cold Press. A type of moderately textured paper.

Crosshatching. Hatched lines crossing over each other.

Drybrush. Painting with relatively dry paint and a dry brush (usually watercolor).

Fan Brush. A brush with a fan-shaped head, used for blending or painting fine, repeated lines.

Flat Brush. A brush with a flat, rectangular head.

Flat Wash. A layer of smooth, ungraded color, usually watercolor.

Gesture. The subject's pose, energy and general essence.

Glazing. Layering paint over a dry area.

Graded Wash. A graded layer of color (usually watercolor) that fades or changes hue toward one end.

Hatching. Closely spaced, parallel line suggesting texture or shadows.

Hot Press. A type of very smooth paper.

Impasto. A technique in which paint is applied so thickly that brushstrokes are clearly visible.

Liner Brushes. A brush with a long narrow head, used for painting lines. Also called a rigger.

Local Color. The actual color of an object, unaffected by shadows, lighting or atmosphere.

Masking. Covering, portion of the work to protect it from any subsequent applications of paint, ink or other medium.

Negative Shapes. The shapes around the subject.

Nib. This is the tip of the ink pen, usually made of metal, though sometimes bamboo or goose quill. The shape and size of the nib determines the shape and size of the line it makes.

Perspective. A technique for depicting scenes and objects so that they appear to have depth and substance.

Plein Air. Working outdoors or on location (literally, open air).

Round Brush. A brush with a round, pointed head.

Scumble. Scrubbing paint onto the surface in a circular motion.

Spatter. Spraying paint drops over a surface.

Spotter Brush. A brush similar to a round, except tiny.

Stippling. Variously spaced dots, used to suggest texture or shadow.

Stump. A tube of tightly rolled paper about the size of a crayon, used for blending graphite and other hard mediums.

Thumbnail. This type of sketch is very small and is used to capture the composition of an image, not the detail.

Tooth. The degree of roughness on a paper's surface. The rougher papers—ones with more tooth—are ideal for powdery mediums like charcoal or pastel. The smoother papers—ones with less tooth—work better for more fluid mediums.

Tortillion. A cylinder of tightly rolled paper about the size of a pencil, used for blending graphite and other hard mediums.

Value. Each hue's inherent darkness or lightness.

Variegated Wash. A layer of one or multiple colors (usually watercolor) applied roughly or unevenly.

Wet-in-Wet. A painting technique (usually watercolor) in which pigment is applied to an already wet area.

Index

The best in fine art instruction and inspiration is from North Light Books!

Through easy-to-follow, step-by-step instructions, exercises and demos, Cathy Johnson tells first-time watercolor painters everything they need to know to begin.

ISBN 0-89134-616-3, paperback, 128 pages, #30724-K

Ruth Glenn Little has drawn upon her 20 years of experience teaching drawing skills to create this wonderful guide for beginners. These lessons allow you to just pick up a pencil and begin learning.

ISBN 1-58180-595-0, paperback, 96 pages, #33108-K

Lee Hammond's easy-to-follow techniques enable even the first-time artists to render a variety of wonderful animals, from cats and dogs to horses, squirrels, tigers and more!

ISBN 1-58180-273-0, paperback, 80 pages, #32144-K

With *Painting Animal Friends*, it's possible to paint cats, dogs, horses, or even ducks without any fine art training at all! There are over 21 different demonstrations of the most popular animals, each with a template line drawing to help you get you started right away.

ISBN 1-58180-598-5, paperback, 128 pages, #33111-K

These books and other fine North Light titles are available at your local fine art retailer, bookstore, online supplier or by calling 1-800-448-0915 in North America or 0870 2200220 in the United Kingdom.